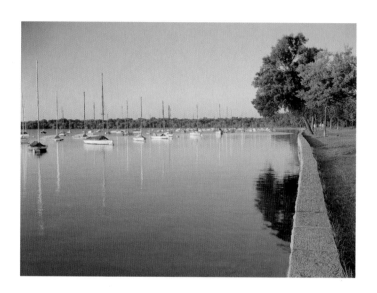

MINNEAPOLIS AND ST. PAUL

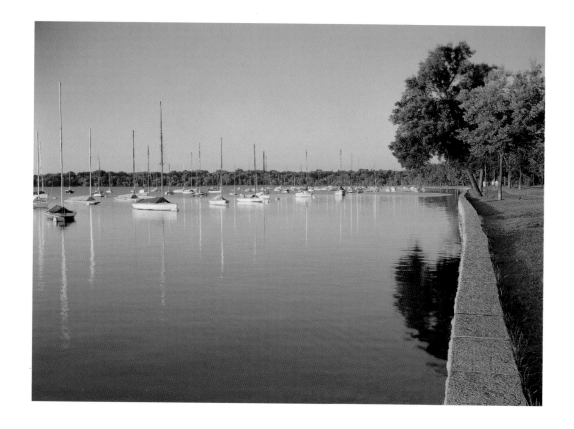

WHITECAP BOOKS

VANCOUVER / TORONTO / NEW YORK

The information in this book is true and complete to the best of our knowledge. All
recommendations are made without guarantee on the part of the author or Whitecap
Books Ltd. The author and publisher disclaim any liability in connection with the use
of this information. For additional information please contact Whitecap Books Ltd.,
351 Lynn Avenue, North Vancouver, BC V7J 2C4.

Text by Tanya Lloyd
Edited by Lisa Collins
Photo editing by Tanya Lloyd
Proofread by Elizabeth McLean
Interior design by Steve Penner
Desktop publishing by Susan Greenshields
Printed and bound in Canada

Canadian Cataloguing in Publication Data

Lloyd, Tanya, 1973–

 Minneapolis-St. Paul

 ISBN 1-55110-948-4

1. Minneapolis (Minn.)—Pictorial works. 2. St. Paul (Minn.)—
Pictorial works. I. Title.
F614.M543L54 1999 977.6'579053'0222 C99-910827-1

The publisher acknowledges the support of the Canada Council and the Cultural
Services Branch of the Government of British Columbia in making this publication
possible. We acknowledge the financial support of the Government of Canada through
the Book Publishing Industry Development Program for our publishing activities.

For more information on the America Series and other Whitecap Books
titles, please visit our web site at www.whitecap.ca.

"Welcome to Pig's Eye!" That's what signs at the city limits may have read had fur trader and settler Pierre "Pig's Eye" Parrant had his way. Fortunately for the Twin Cities, Father Lucian Galtier arrived in 1841. He christened his log church "St. Paul" and the name was soon adopted by his neighbors. Less than a decade later, this was the capital of the new territory of Minnesota.

St. Paul's "twin city" may have had a slower start, but it soon established a firm reputation as a commercial power. Franklin Steele planned St. Anthony—the first settlement on this site—in 1849, and by the late 1860s, more than a dozen mills were churning out lumber near St. Anthony Falls. The railroad's arrival boosted the success of Minneapolis, ideally positioned between St. Paul and the rich agricultural regions. Eventually, in 1872, Minneapolis encompassed St. Anthony. For the next decade, this was the flour milling capital of the world.

Today, Minneapolis and St. Paul are centers of both industry and culture. Equally captivating but far from identical, the Twin Cities regularly win awards for the lifestyle and opportunities they offer. Well over 100 galleries dot the region, and residents attend more theater events per capita than any American city outside New York. Award-winning architecture such as that of the World Trade Center soars over stately turn-of-the-century buildings and millions of visitors each year wander the historic districts. From elegant performances at the Ordway Music Theater and the colorful distractions of the Mall of America to the tranquil shores of Lake Como and the beauty of Minnehaha Falls, these thriving cities have something for everyone.

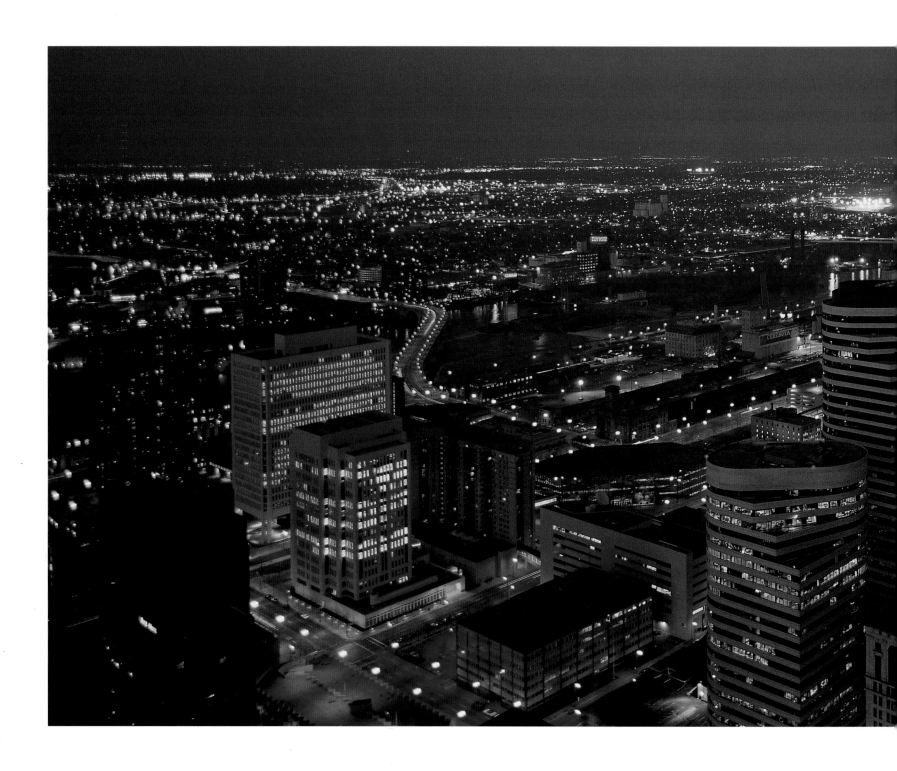

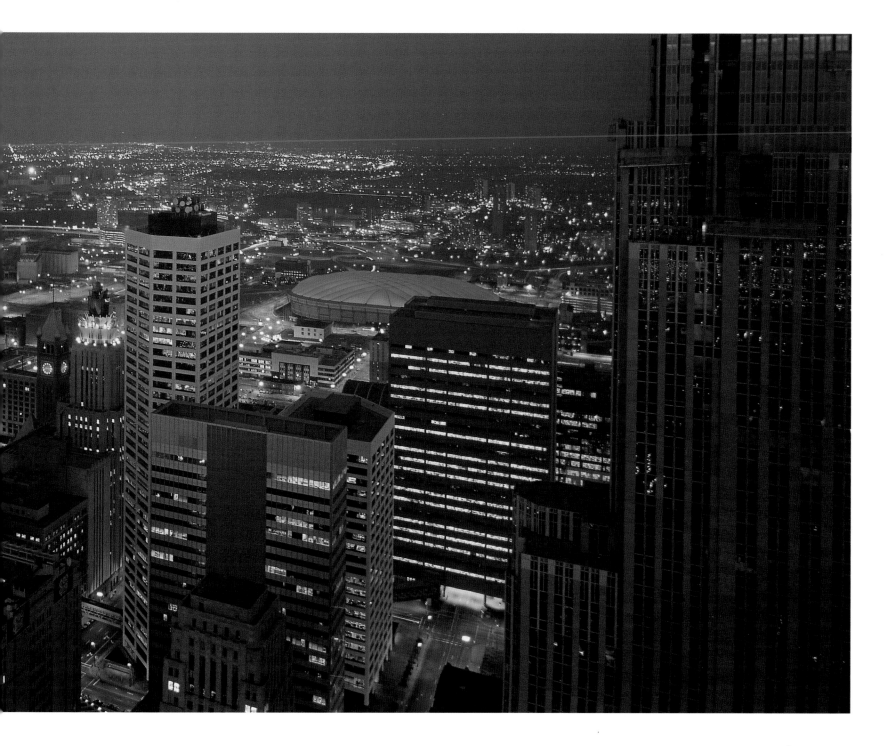

More than 360,000 people live in Minneapolis. A large student population, active nightlife, three professional sports teams—baseball, football, and basketball—and numerous events and festivals make the city a lively place.

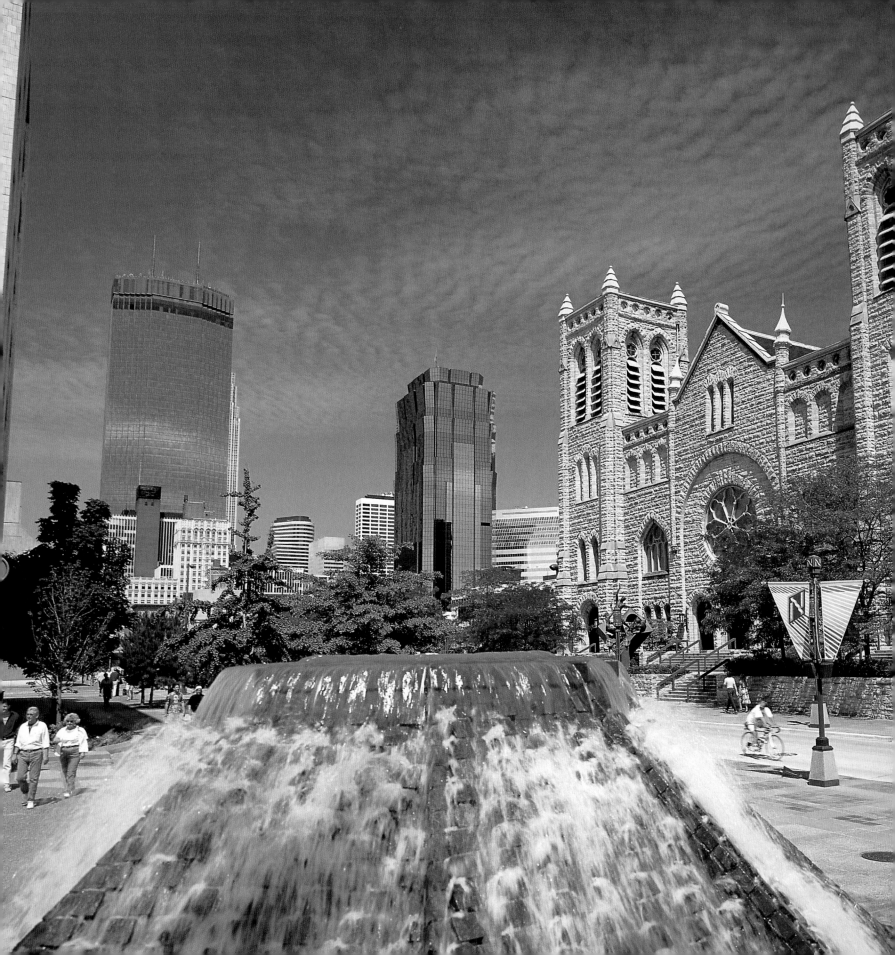

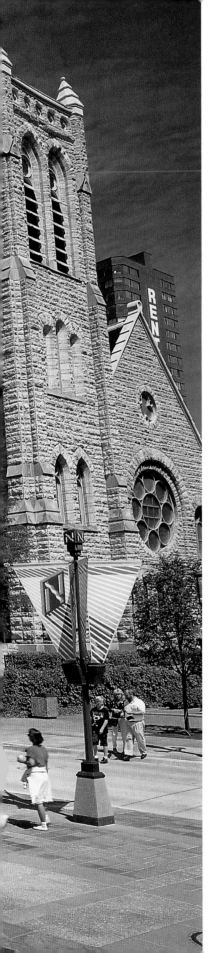

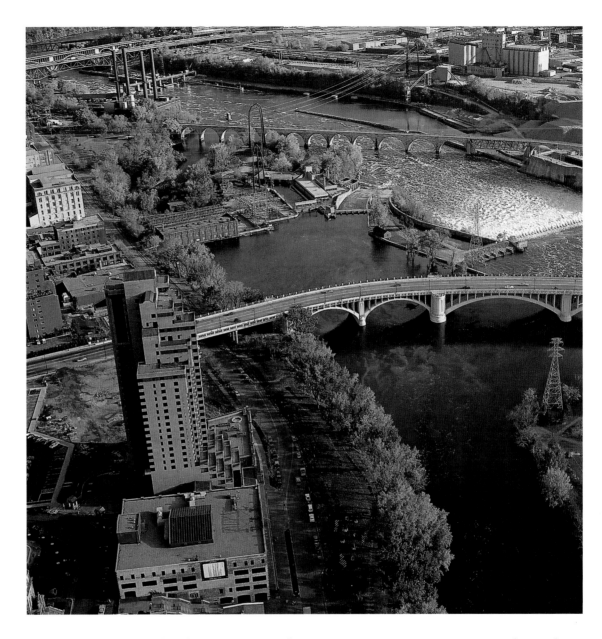

One of the oldest bridges crossing the Mississippi River, Stone Arch Bridge took 600 workers two years to build. It was completed in 1883.

Westminster Presbyterian Church has one of America's largest congregations. Built in 1897, the church can seat 1,500 people. It stands on Nicollet Mall, Minneapolis's famous pedestrian shopping district.

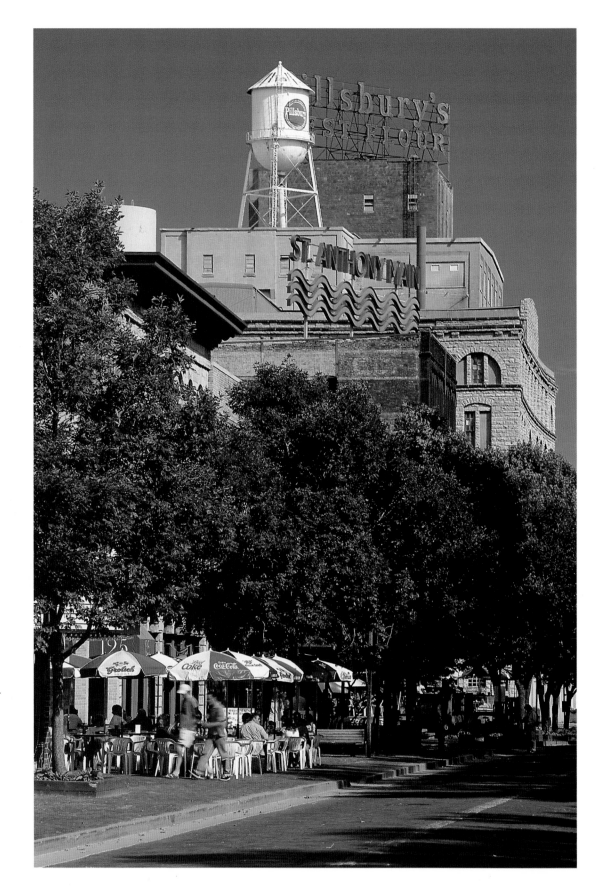

St. Anthony Falls was originally used as a power source for large flour mills. Some of these mills eventually grew into multinational corporations such as Pillsbury and General Mills—organizations still based in Minneapolis.

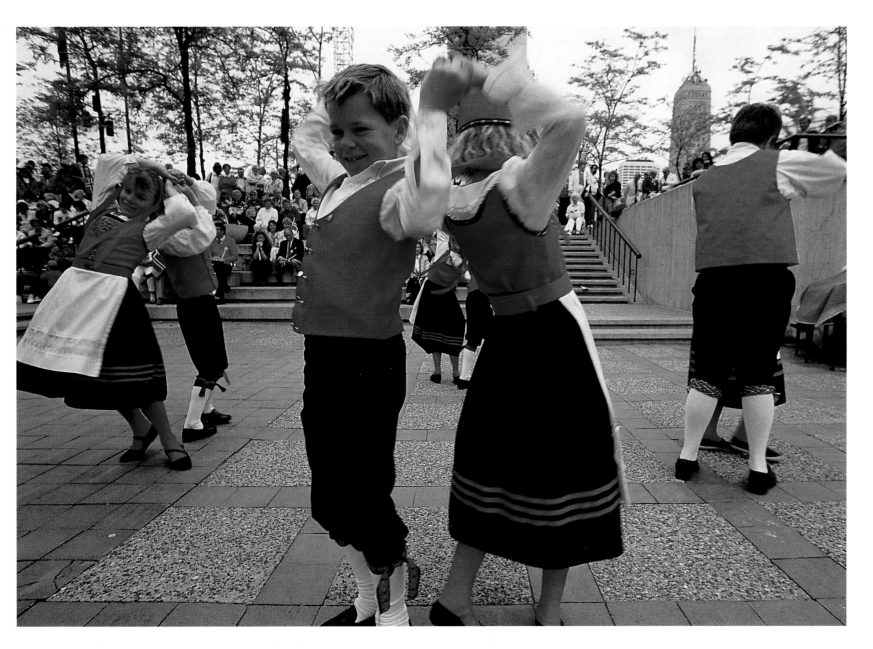

In the late 1800s, thousands of Scandinavian settlers flocked to Minnesota's rich farmland. In May, their descendants celebrate Syttende Mai, Norwegian Constitution Day, with a parade, traditional dances, and other lively events.

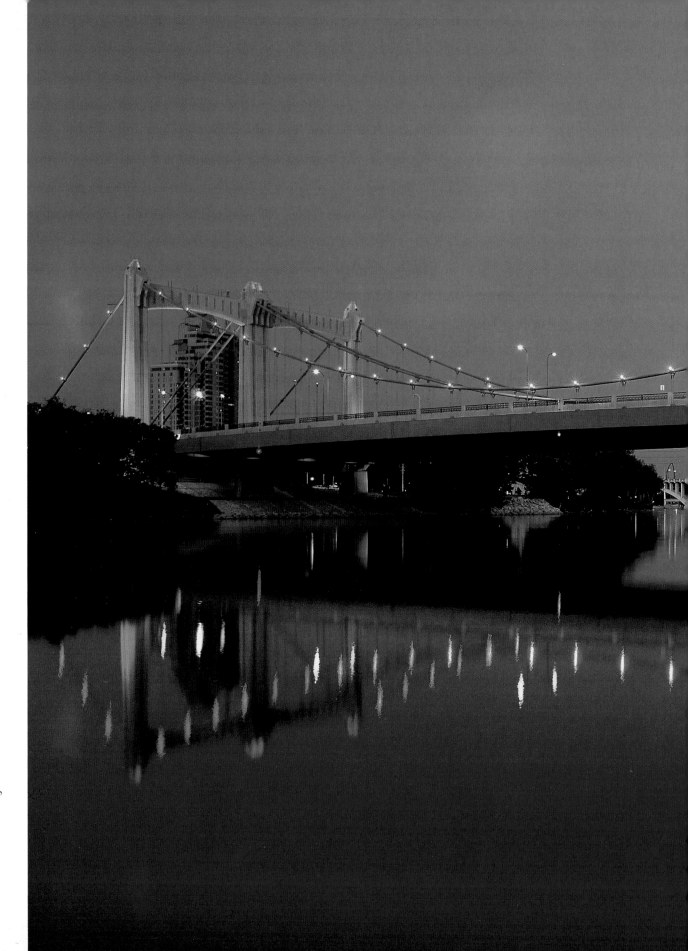

Lights glitter on the Hennepin Avenue Bridge. The avenue is named for Father Louis Hennepin who, in 1680, became the first European to see St. Anthony Falls.

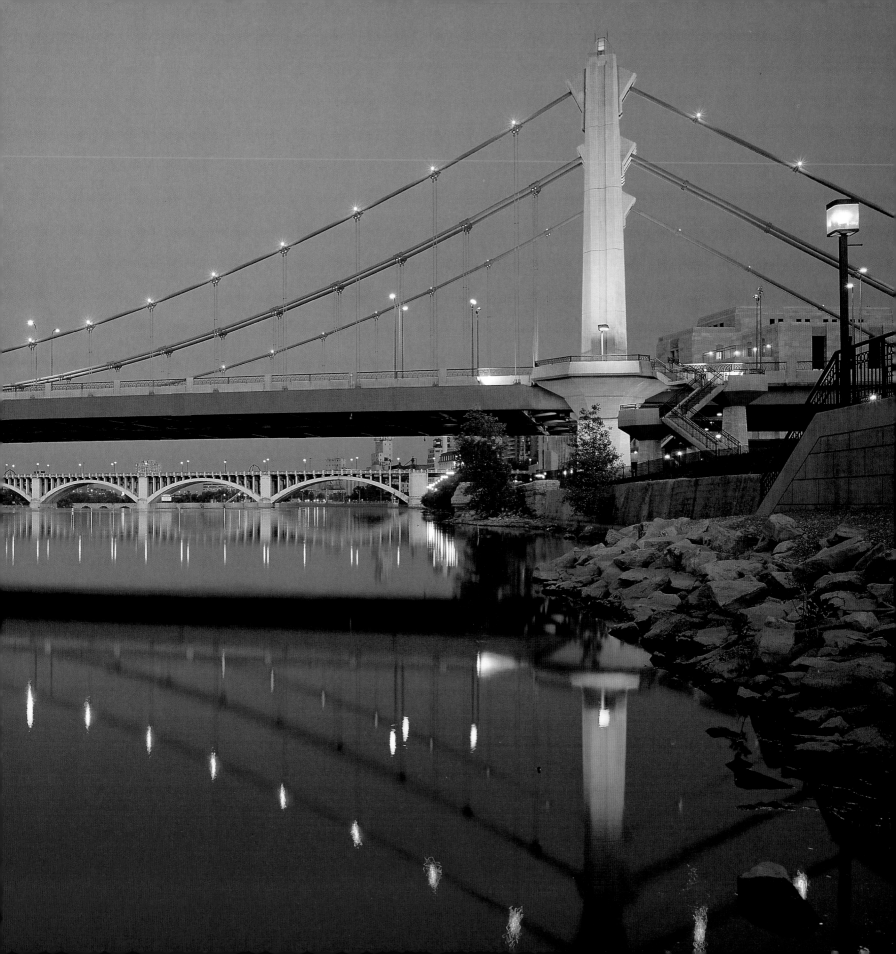

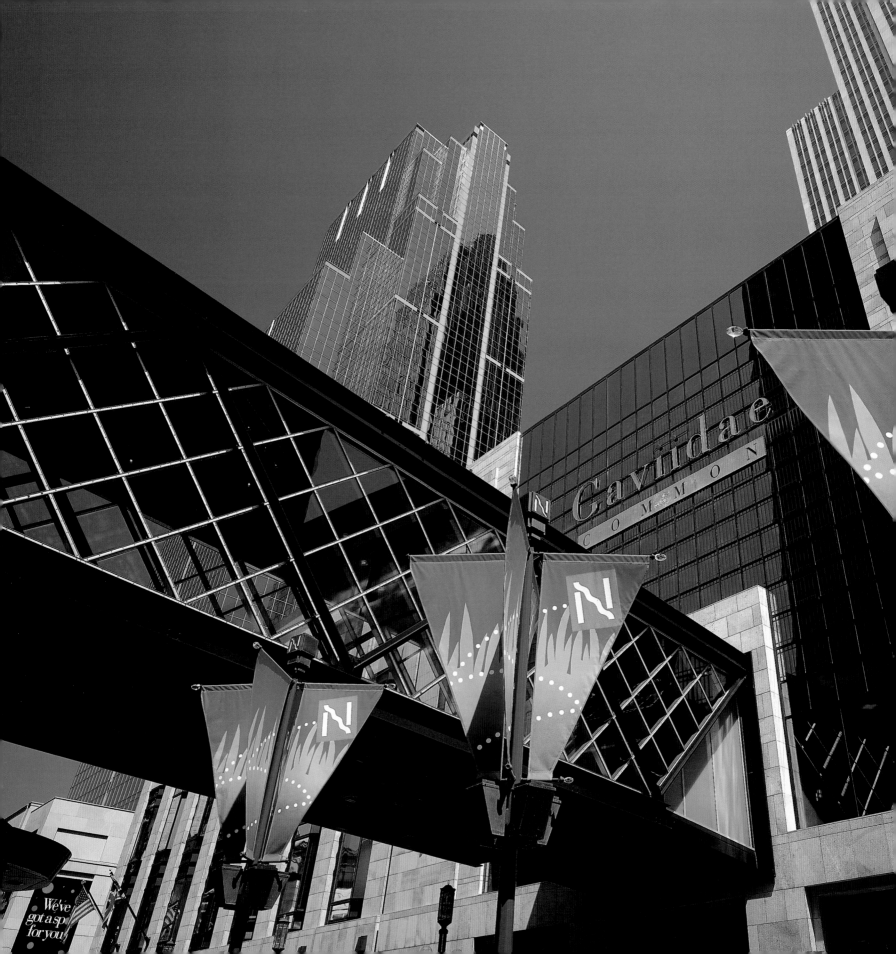

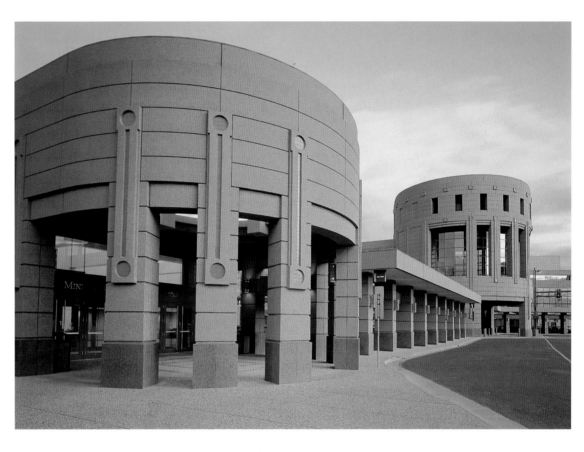

The world's largest copper-domed building, the Minneapolis Convention Center is one of the city's most recognizable landmarks. Six football fields would fit within the center's exhibition halls.

Gaviidae Common, a retail and entertainment center, is just one of the locations linked by Skyways, an enclosed system of second-story walkways designed to stave off Minnesota's harsh winters.

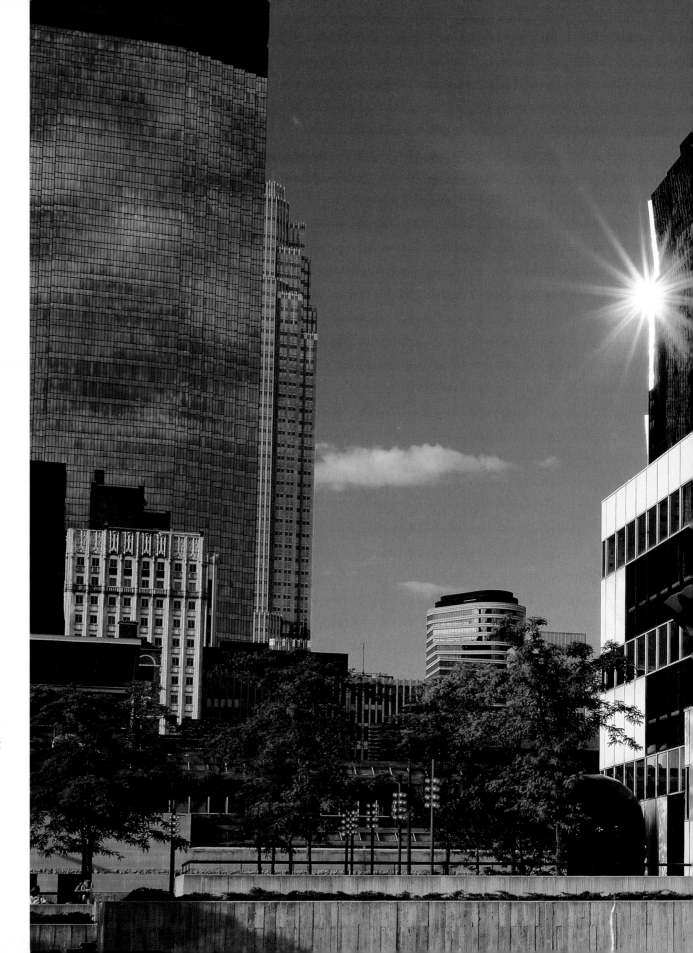

Orchestra Hall hosts over 225 performances yearly, many by the Minnesota Orchestra. New York City is the only place in the U.S. where a greater percentage of the population attends theater and cultural events.

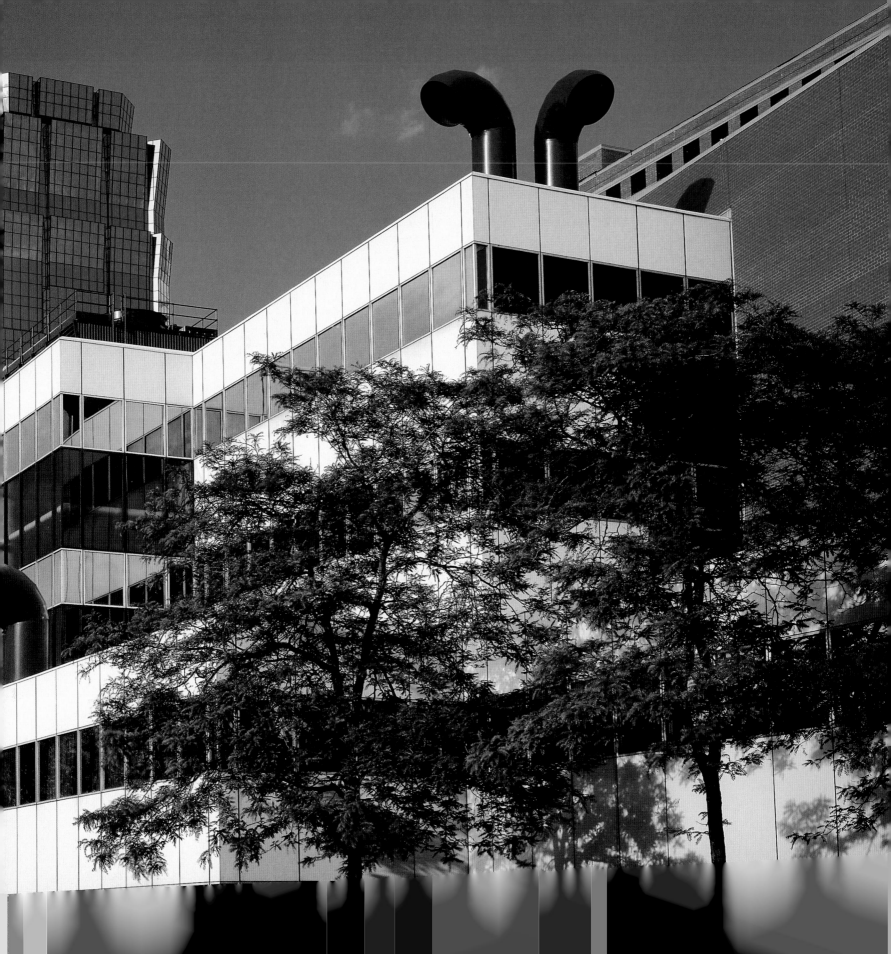

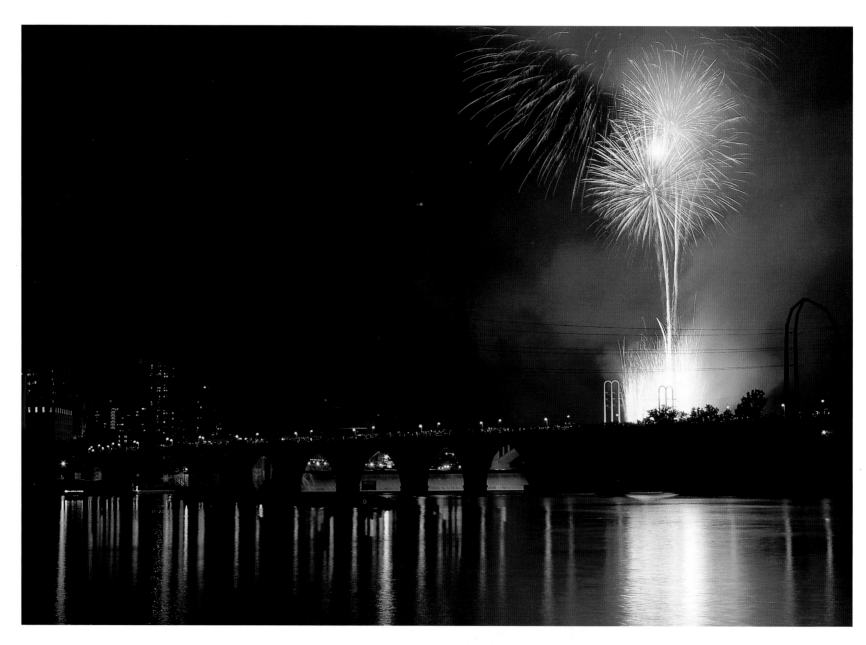

A surprising number of inventions were born in Minneapolis. Some—such as Wheaties and Bisquik—reflect the city's proximity to Minnesota's wheat fields. Others, such as Scotch tape and Post-it, are more surprising.

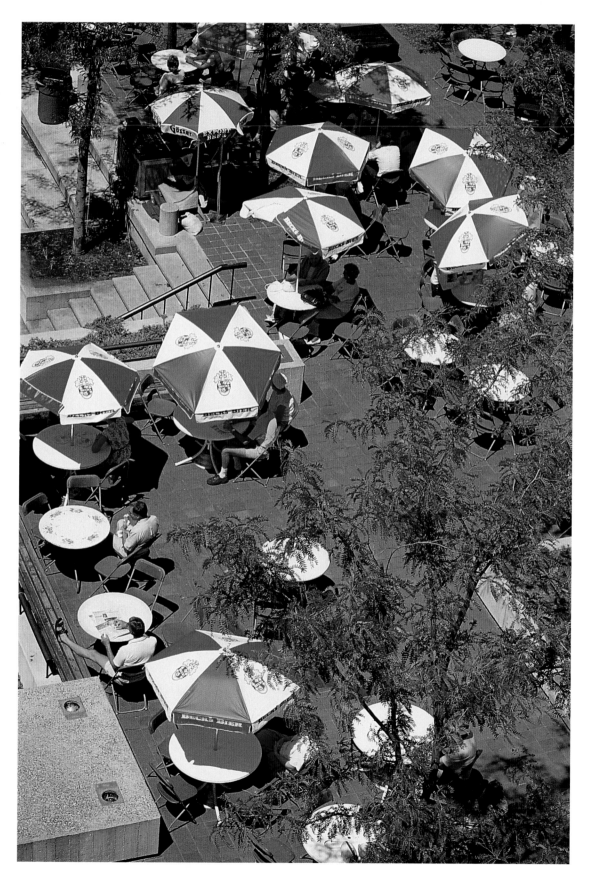

Peavey Plaza is transformed into a Viennese *marktplatz* each July. The annual Viennese Sommerfest includes more than 30 classical music performances, food tents, and street entertainment.

The Minneapolis Aquatennial is a 10-day, city-wide celebration held each July. About 800,000 people enjoy festivities as varied as a milk-carton boat race and a torch-light parade.

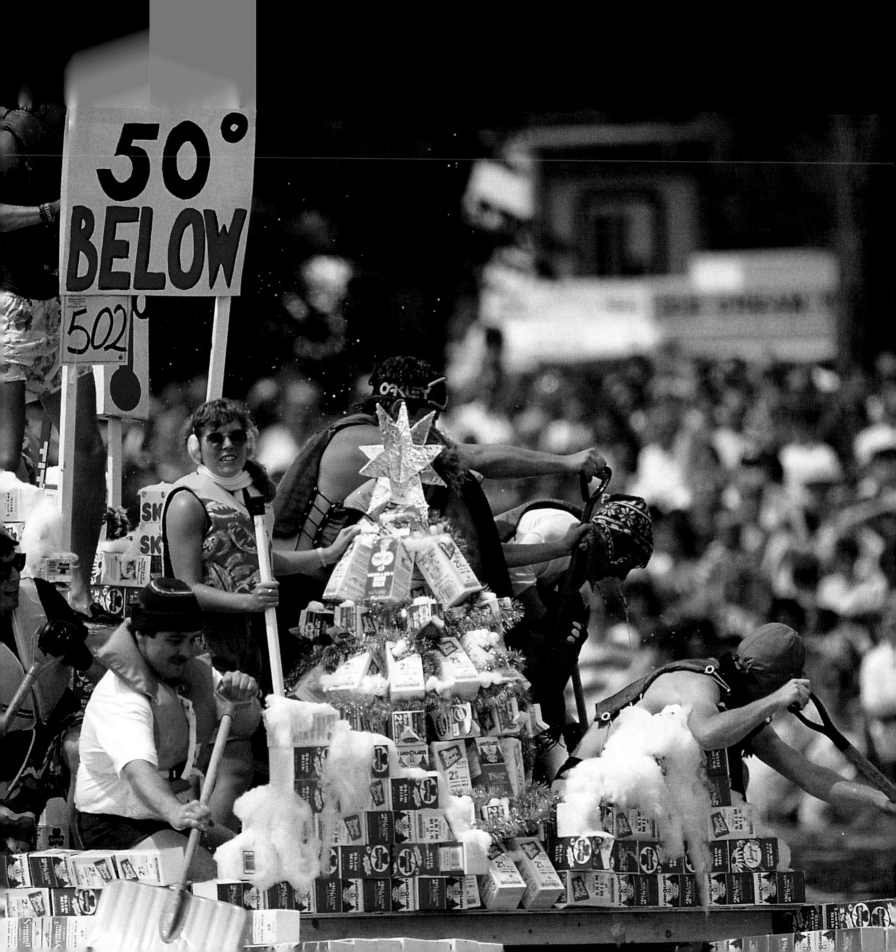

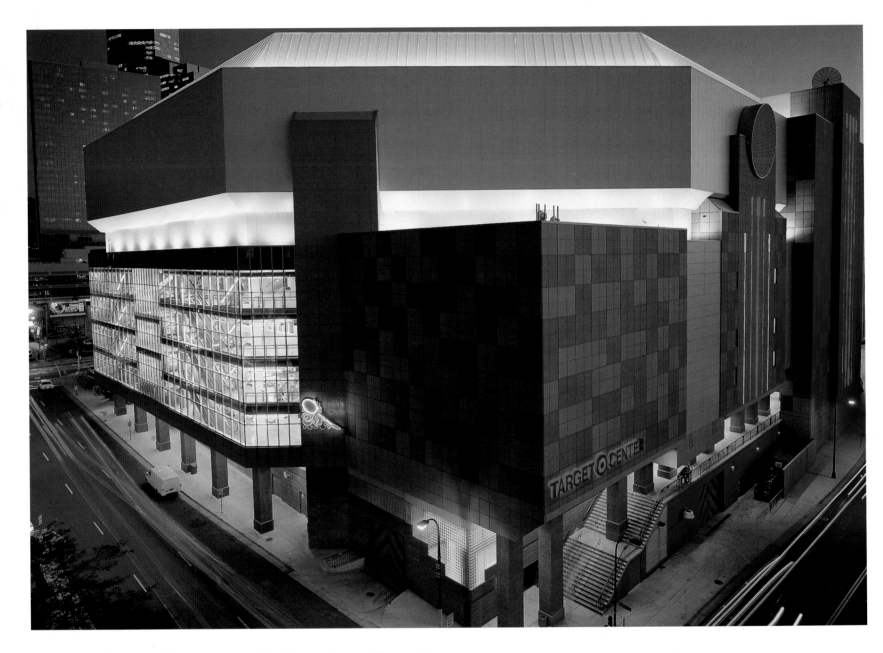

Home to the NBA's Minnesota Timberwolves, Target Center was
built in 1990. The building seats 20,000 spectators and boasts the
nation's first movable ice floor.

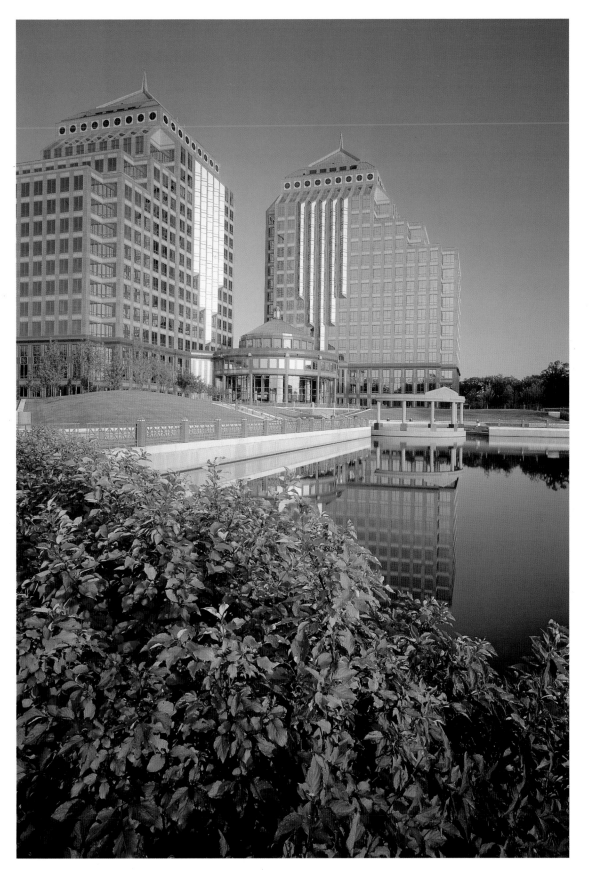

The headquarters for more than a dozen Fortune 500 companies, including Honeywell, Northwest Airlines, and the Dayton Hudson Corporation, are located in Minneapolis.

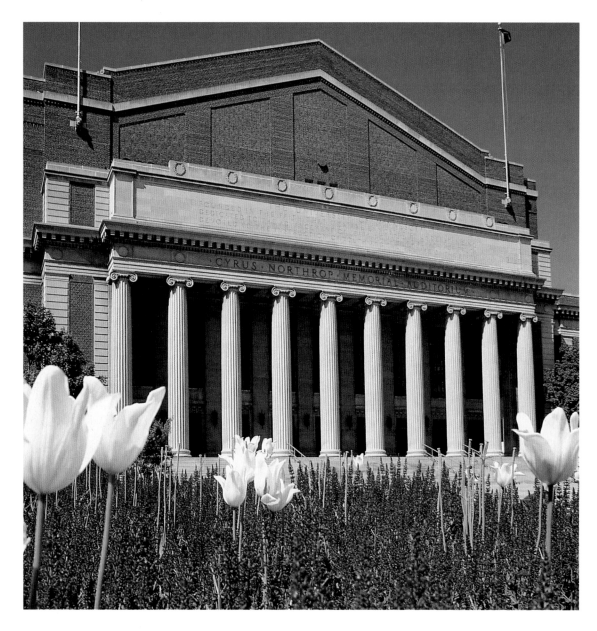

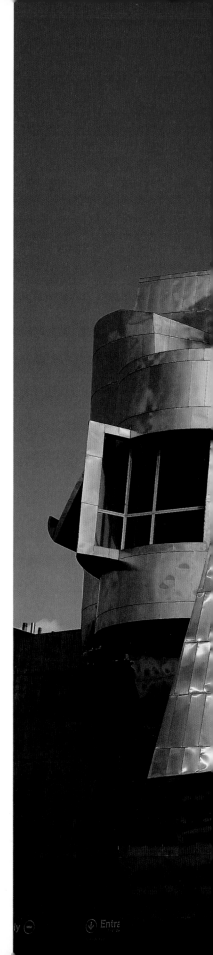

The University of Minnesota was established in 1851—five years before Minneapolis was incorporated. With more than 58,000 students, it is the largest university in the country.

The dramatic stainless steel walls of the Weisman Art Museum were designed by Frank Gehry. The building opened its doors in 1993. It houses more than 13,000 works.

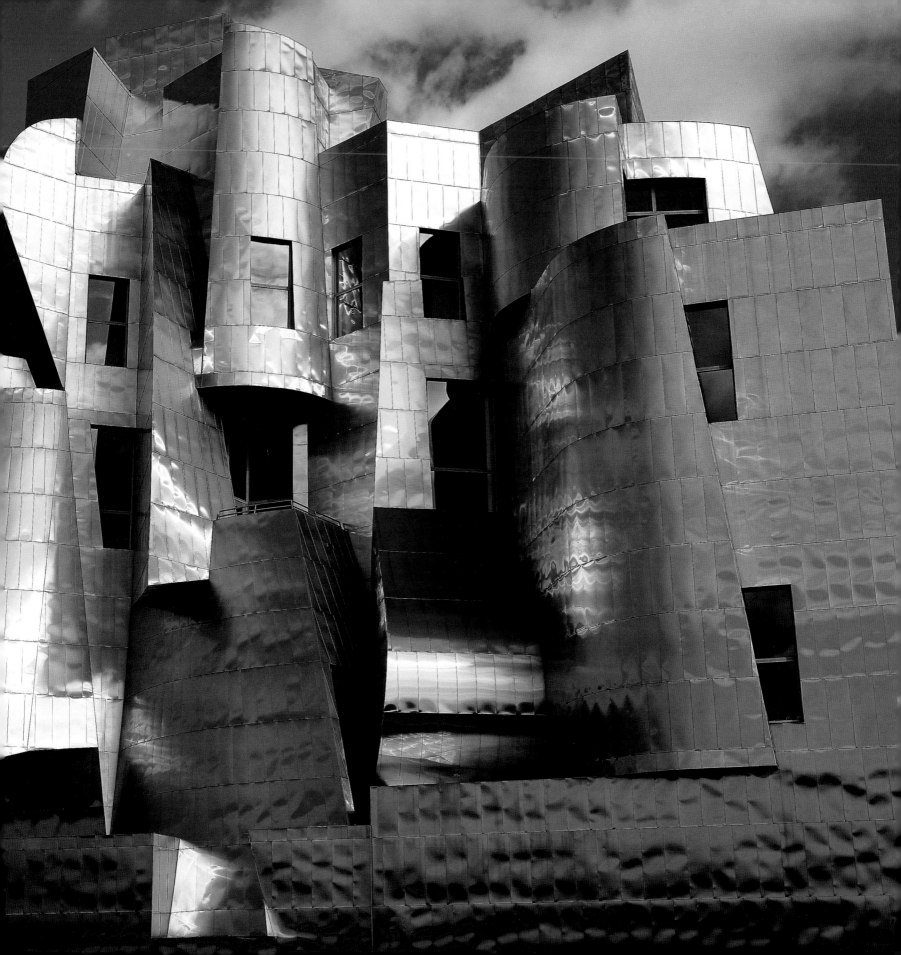

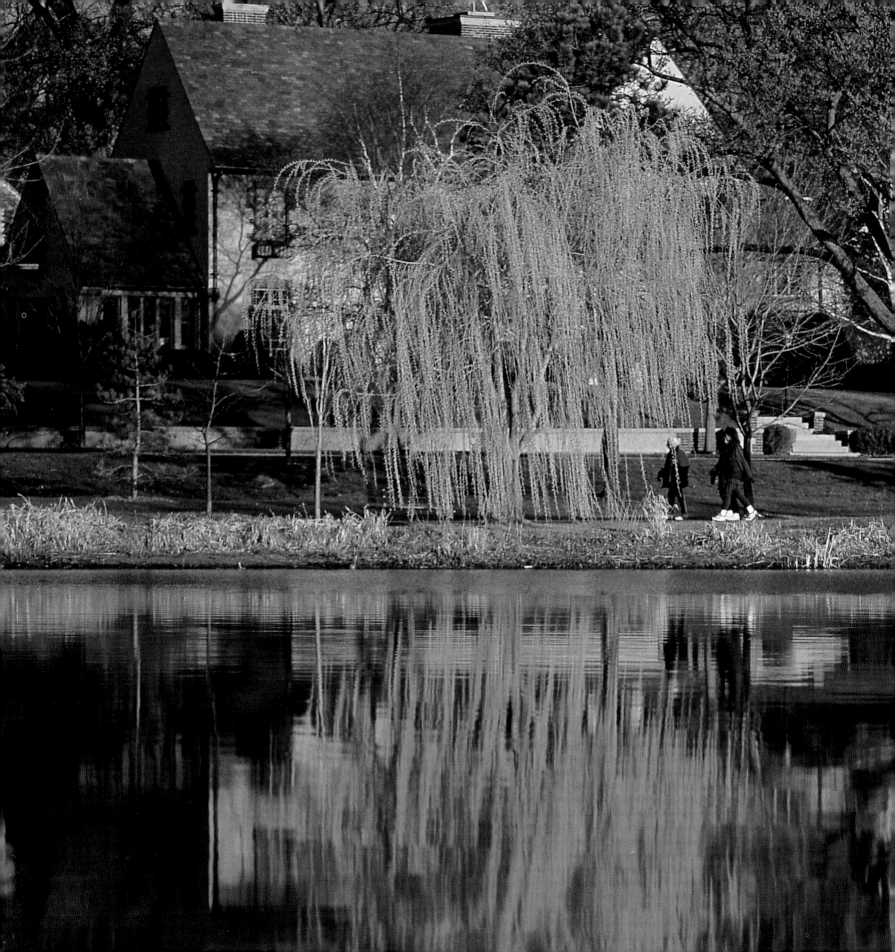

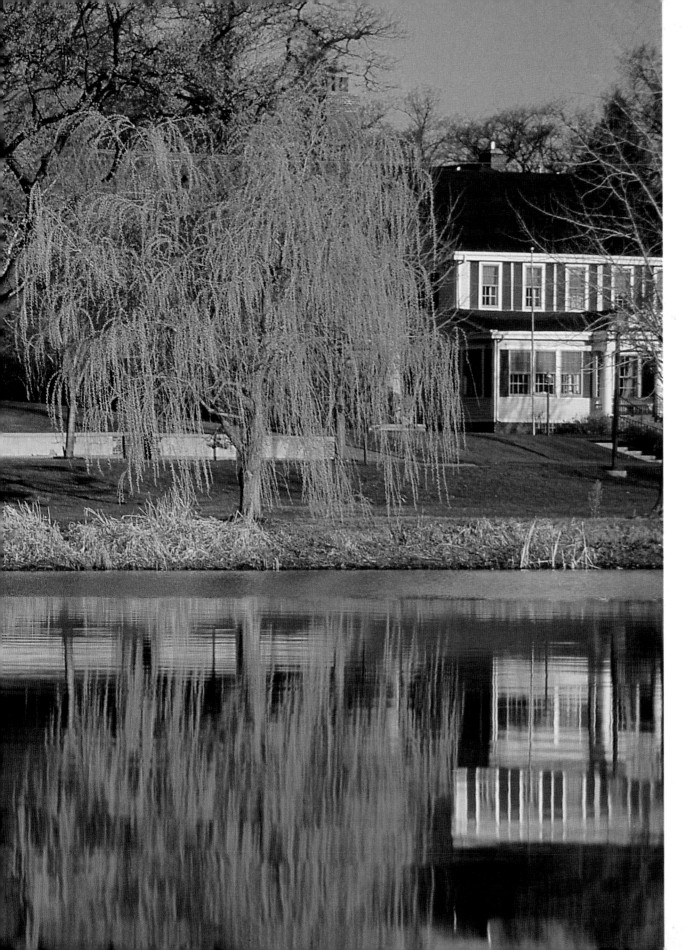

The shallow Lake of the Isles was once marshland. It was dredged in the 1880s, and the surrounding area has since become one of Minneapolis's most desirable neighborhoods.

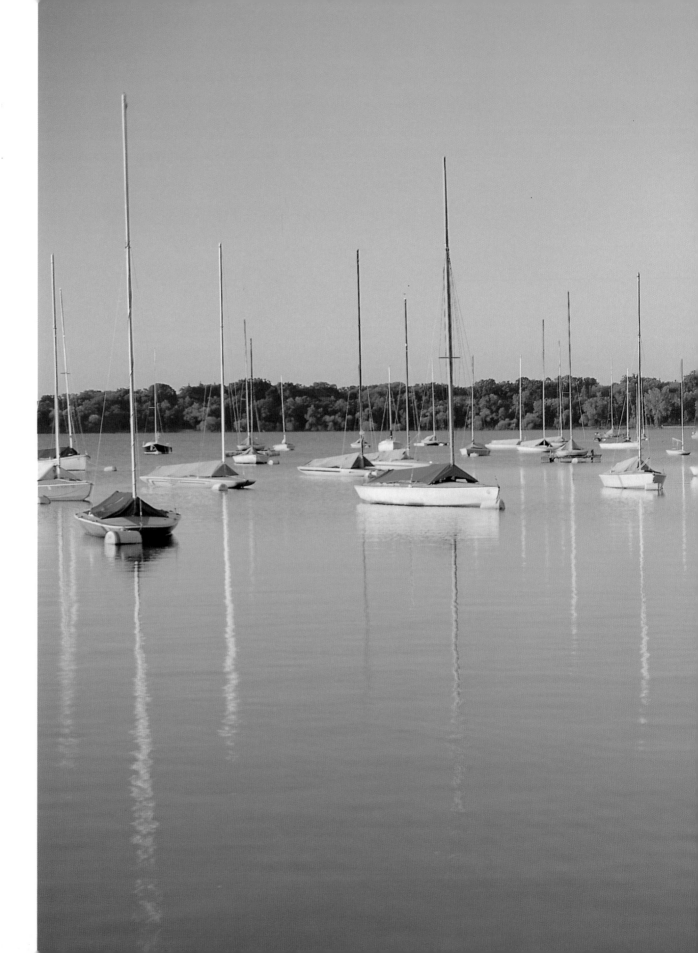

More than 35 miles of walking paths wind around the lakes, along with another 38 miles of bike paths.

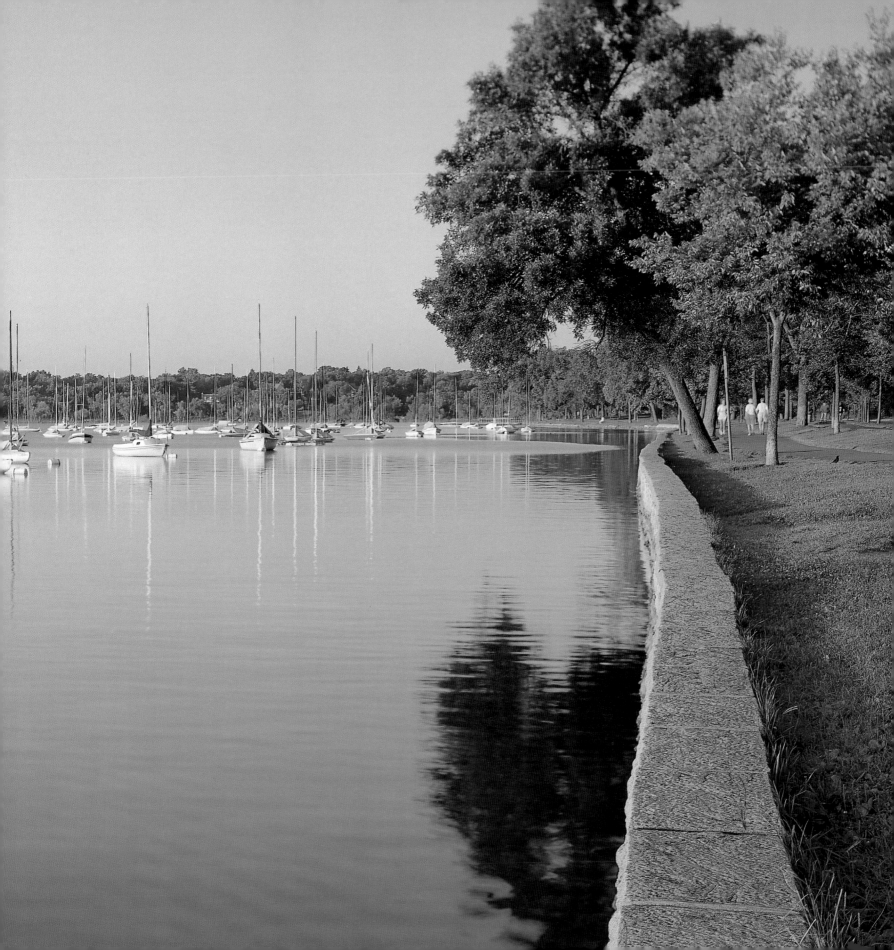

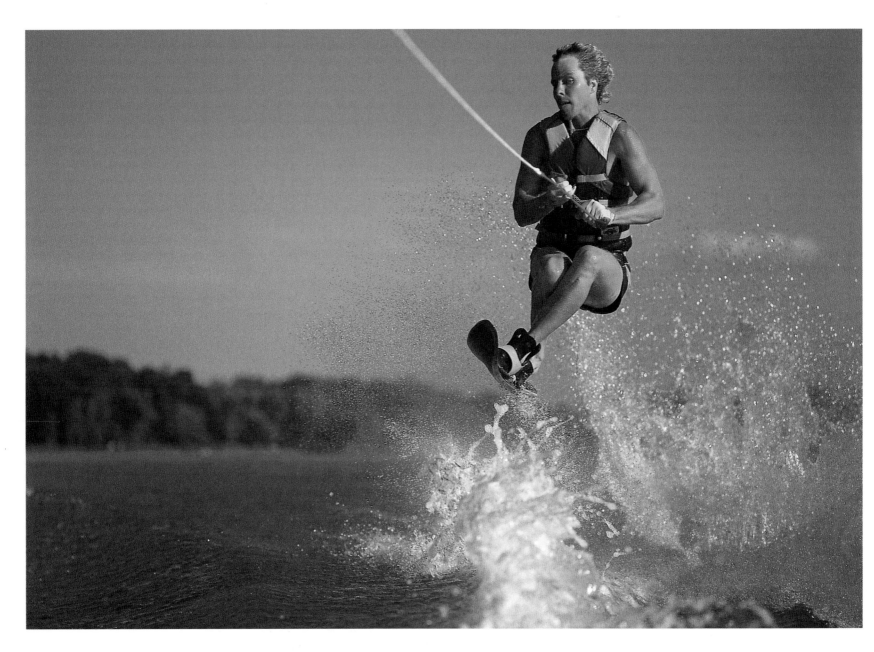

There are 18 lakes within the city of Minneapolis. In fact, *minne* means "water" in the Native Dakota language and *polis* is the Greek word for "city."

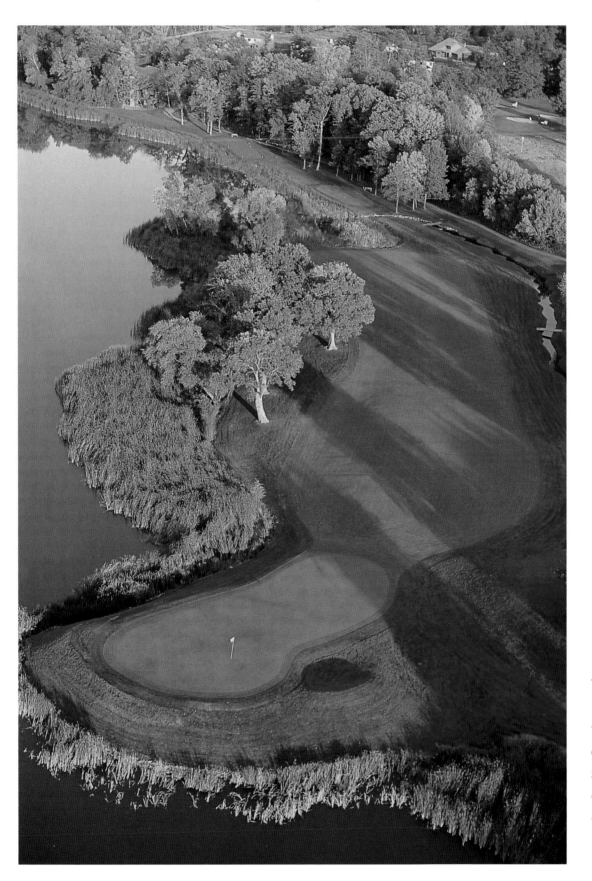

There are more than 125 golf courses within the Minneapolis and St. Paul area and more par-3 courses than in any other city.

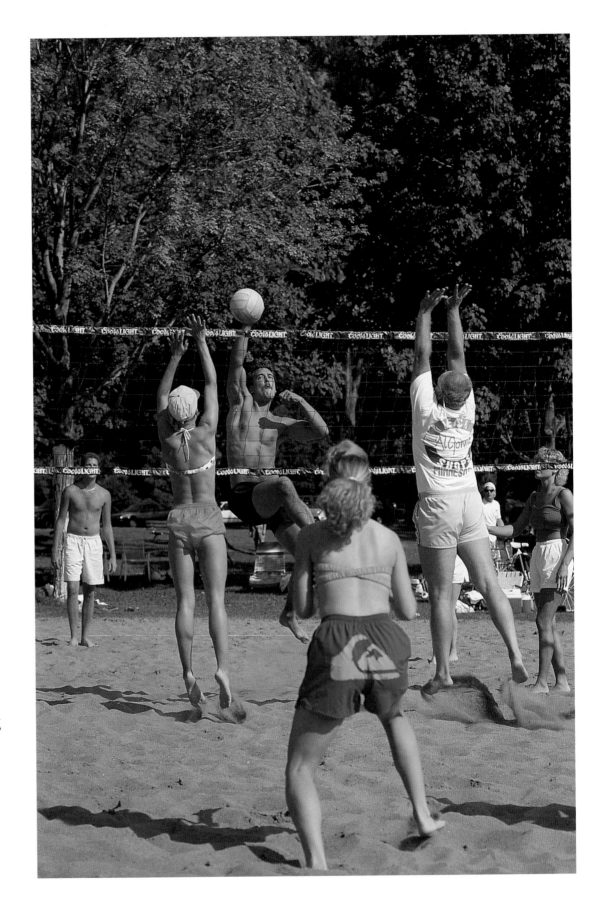

Minneapolis boasts one acre of parkland for every 57 residents—an amazing ratio and part of what encourages so many residents to participate in recreation and sports events around the city.

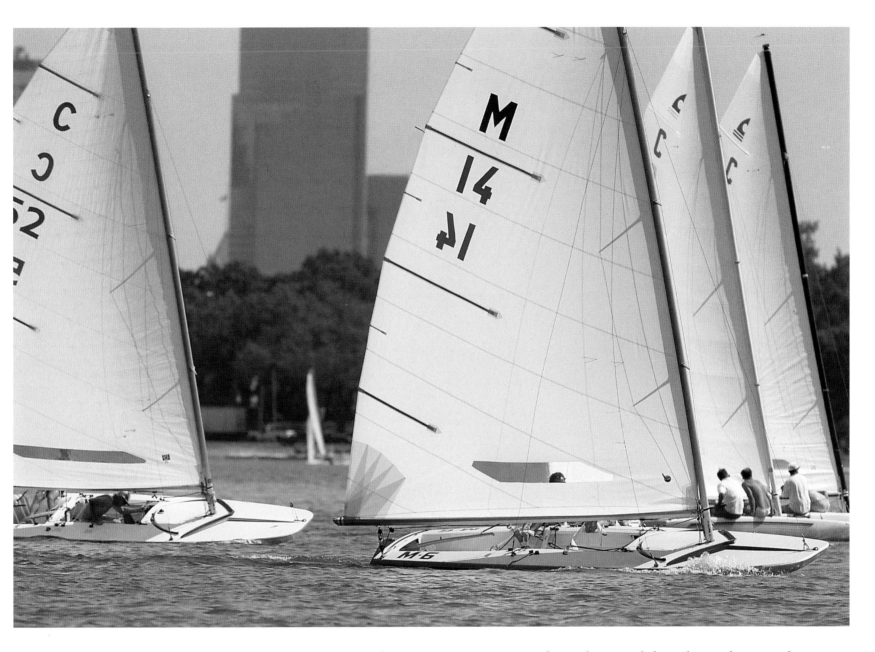

Powerboats are not permitted on the city lakes, but a breezy day is perfect for sailing or windsurfing. Enthusiasts flock to Lake Calhoun, the largest of the waterways.

Charles M. Loring was the first president of the Minneapolis Parks Board. Thirty-six-acre Loring Park was named in his honor.

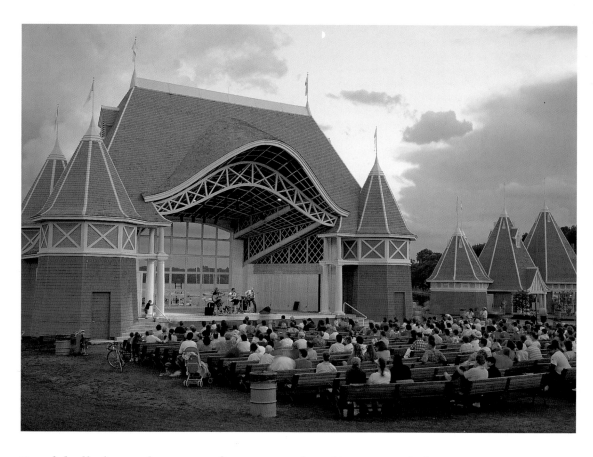

Bandshells have drawn performers and audiences to Lake Harriet since 1888. The present fairytale structure was designed in 1988 by Milo Thompson.

The Linden Hills neighborhood has a charming small-town atmosphere. New buildings stand amongst turn-of-the-century homes and cottages.

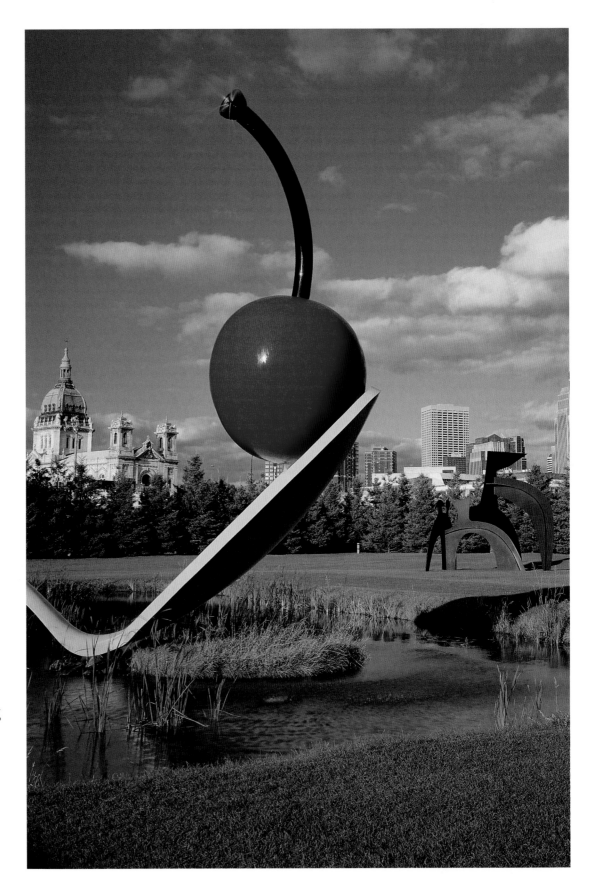

Spoonbridge and Cherry, created by Claes Oldenburg and Coosje van Bruggen, is over 50 feet high. It is one of more than 40 works on display at the Minneapolis Sculpture Garden.

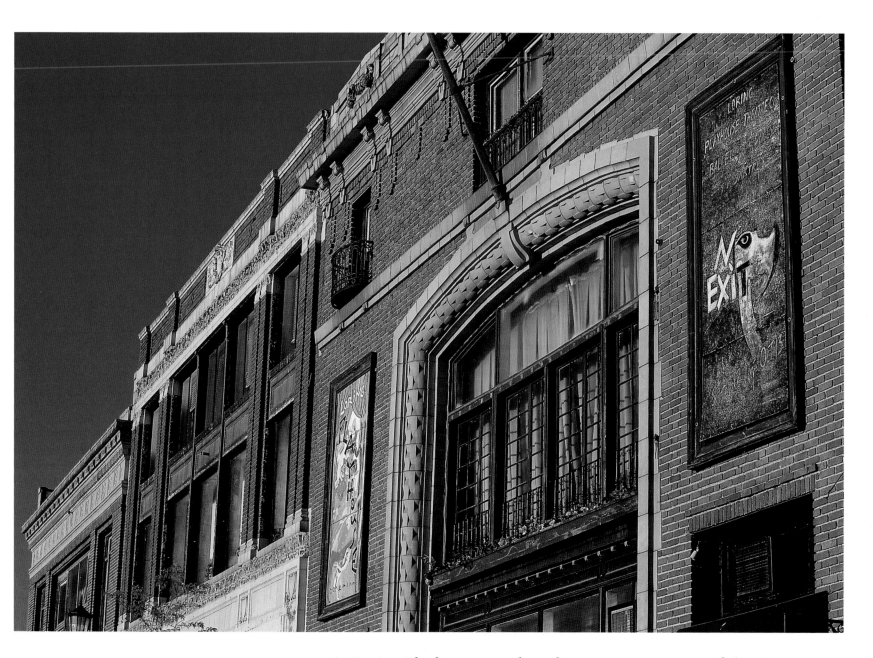

At Loring Playhouse, resident theater company Eye of the Storm produces an array of works by local and national playwrights. It is one of more than 40 theater venues in the city.

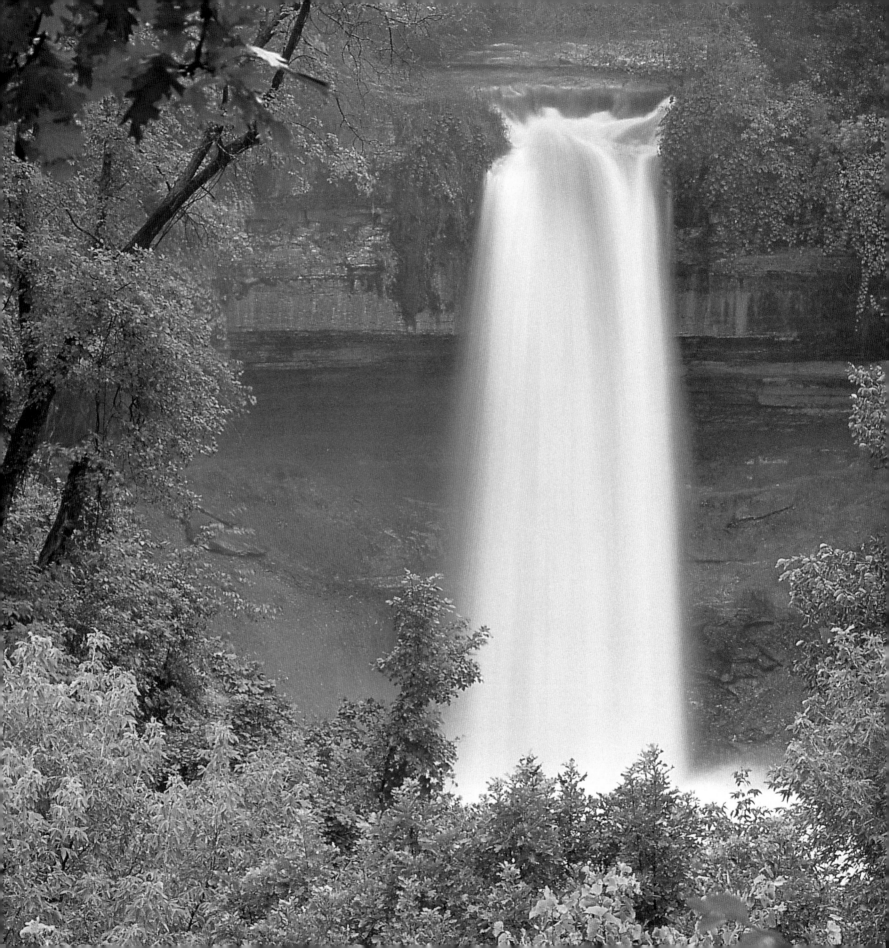

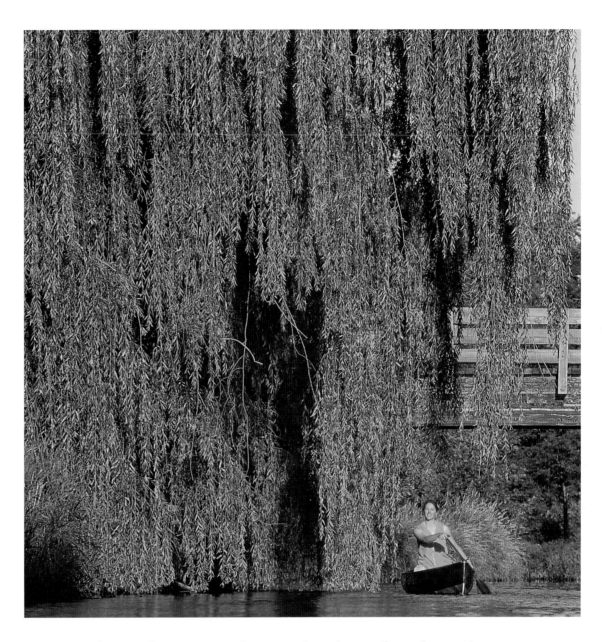

Minneapolis residents aren't alone in their love of outdoor adventure. Ninety-five percent of Minnesota's population lives within five miles of recreational lakes or rivers.

The legendary beauty of Minnehaha Falls is said to have inspired poet Henry Wadsworth Longfellow to write *Song of Hiawatha*. The name of the falls means "laughing waters" in the language of the Dakota people.

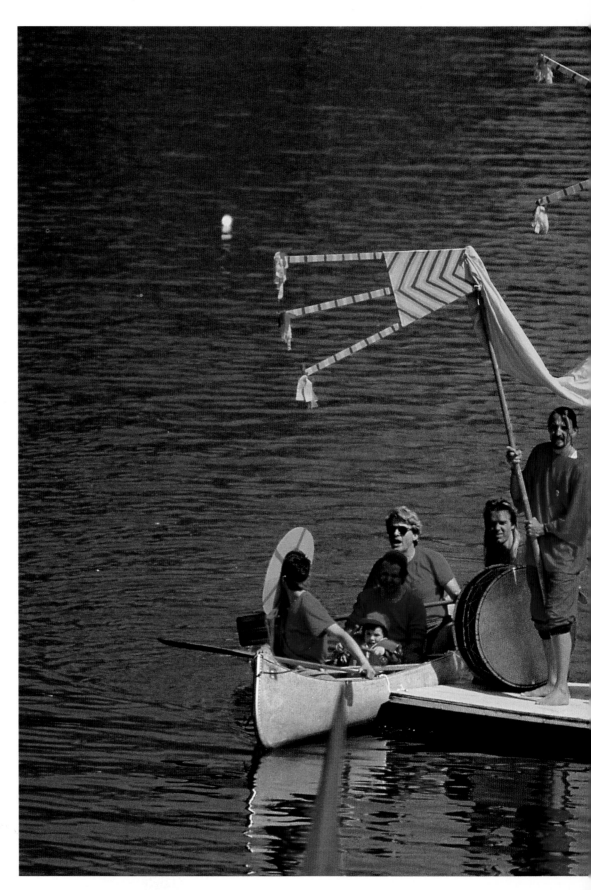

This dazzling display is part of Mayday festivities at Powderhorn Park. The annual event includes a parade of 15-foot, custom-made puppets.

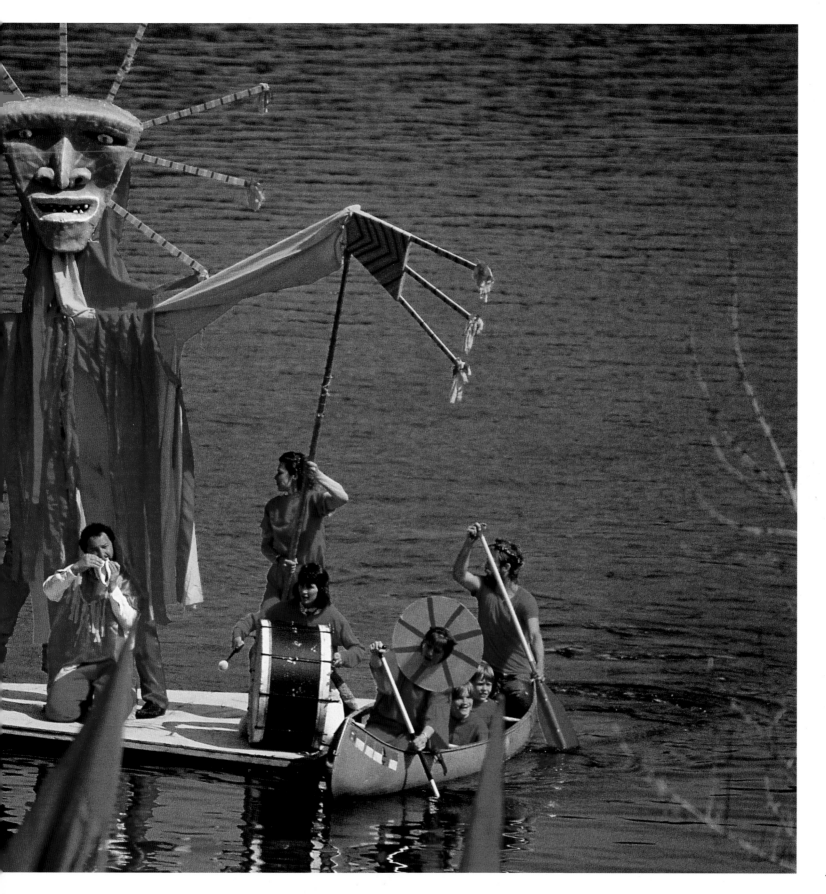

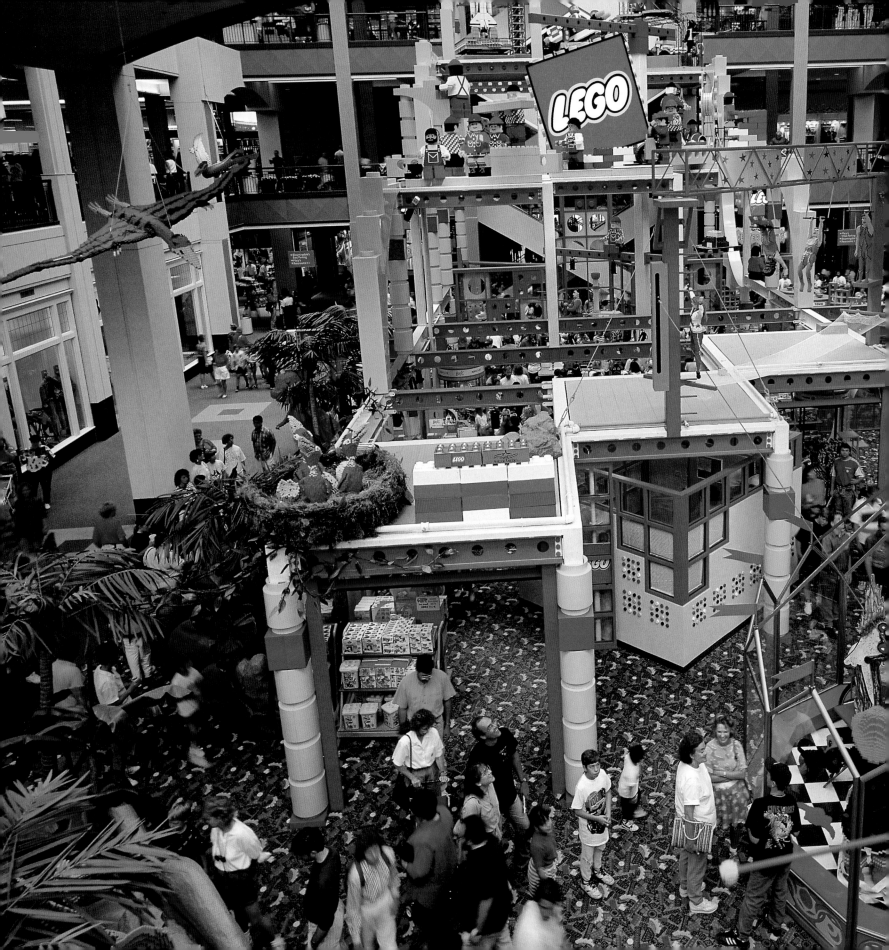

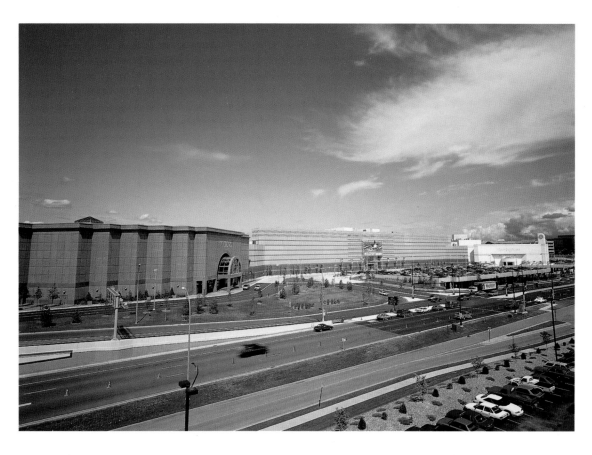

Mall of America, encompassing 4.2 million square feet, opened in 1992. The mall includes more than 500 stores, a mini-golf course, a theme park, and an aquarium with 15,000 water creatures.

On display at the LEGO Imagination Center, young explorers find dinosaurs, a space shuttle, a blimp, and a 20-foot clock tower—60 giant-sized models in total.

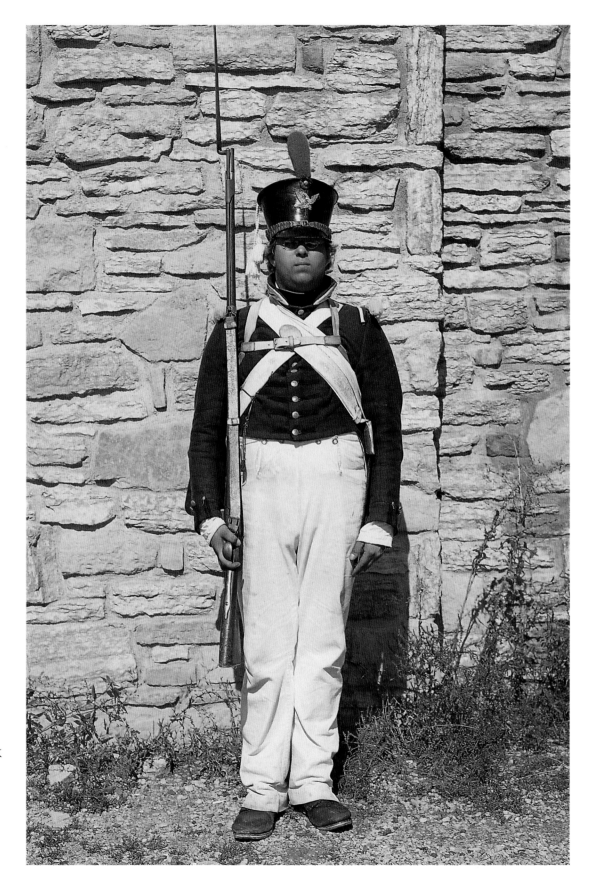

Fort Snelling was built in
1825 to protect America's
control of the Mississippi
and Minnesota rivers.
Designated the state's first
National Historic Landmark
in 1960, the fort protects
some of Minnesota's oldest
buildings.

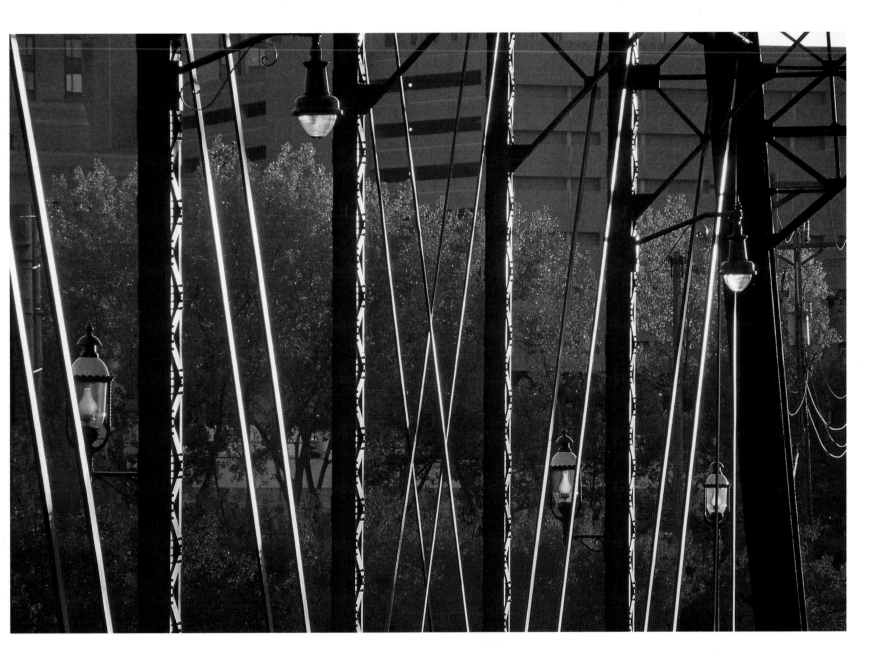

St. Anthony Bridge is one of many spans across the Mississippi River. The lamps lining the bridge add to the historic flavor of the city's riverfront district.

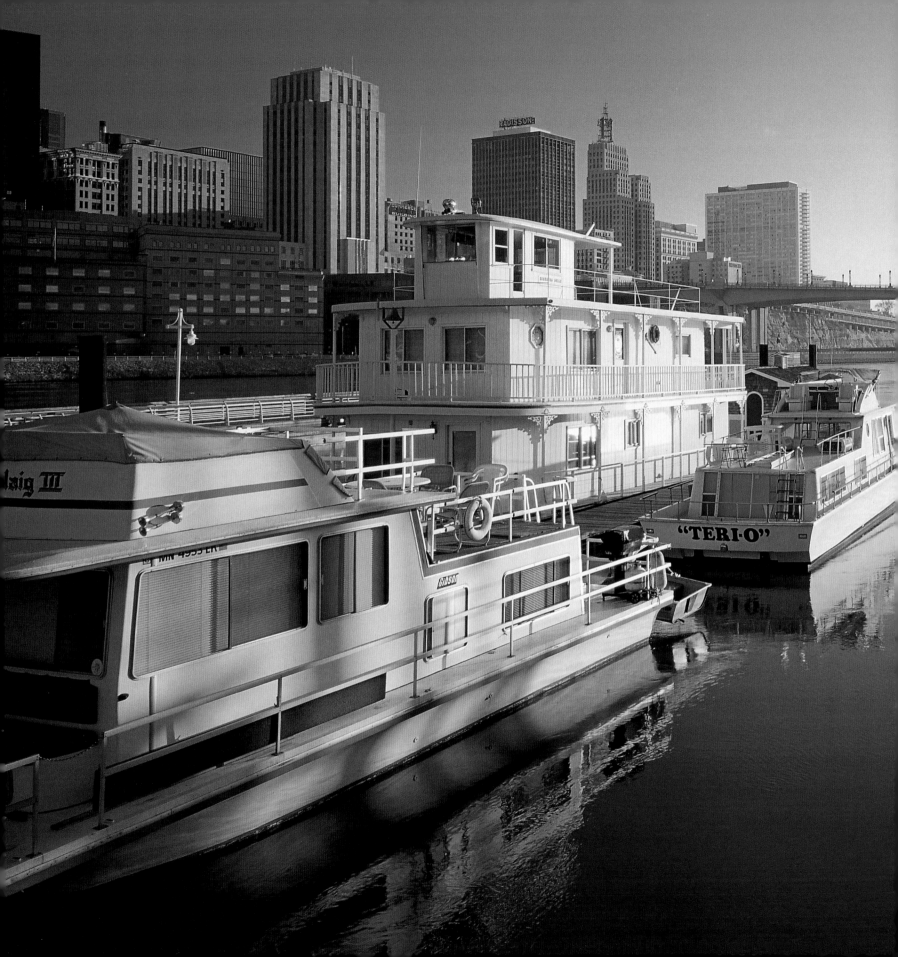

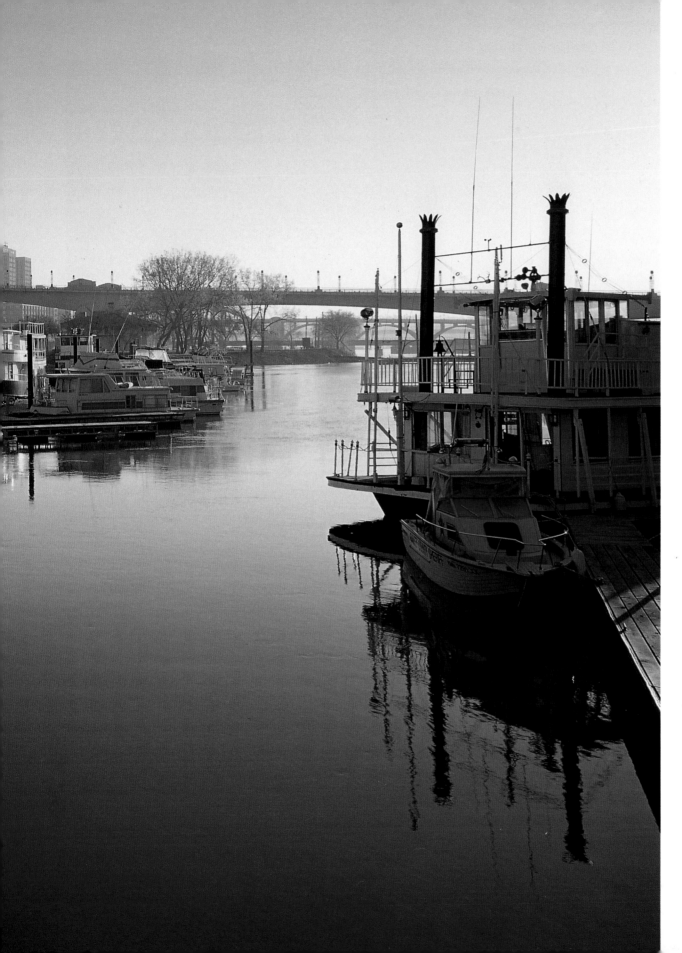

The shores of the Mississippi were once a place of mystery. When explorer Jean Nicolet travelled these waters in the 17th century, he brought formal robes in hopes of finding the Northwest Passage and meeting the ruler of China.

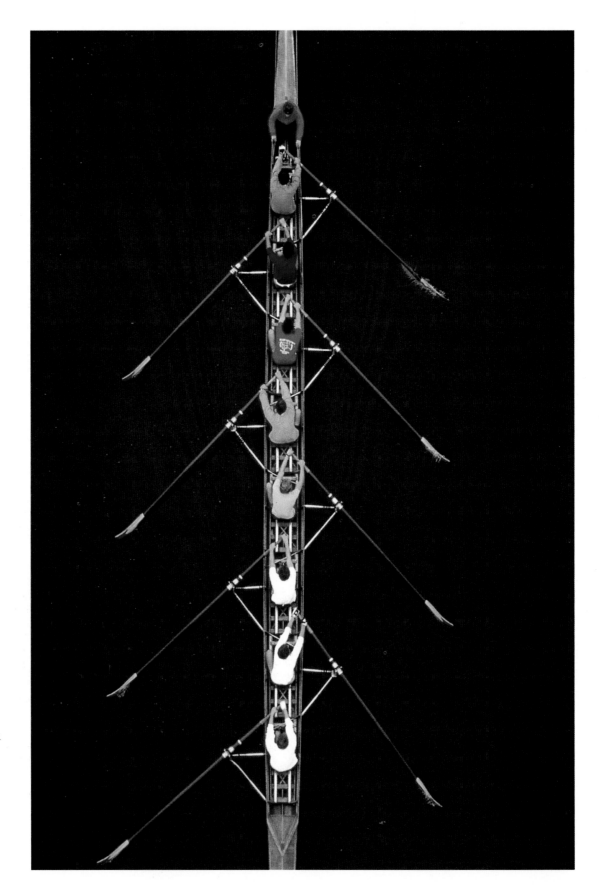

Dawn often finds the University of Minnesota rowing teams practicing on the Mississippi River. Both men's and women's teams compete nationwide, often with impressive results.

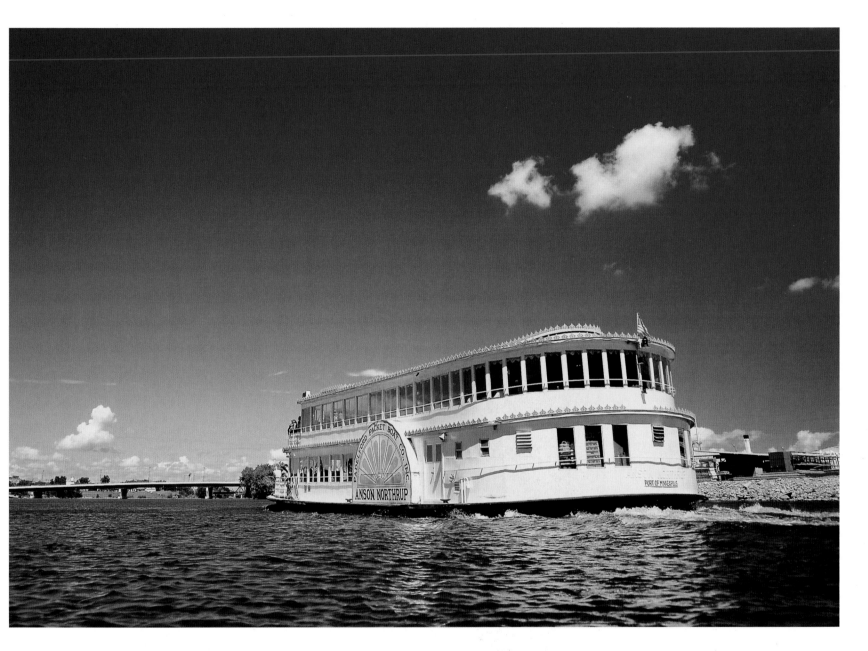

Visitors seeking a glimpse of history enjoy a cruise on a 19th-century sternwheeler down the Mississippi River from St. Paul to Fort Snelling. A narrated tour offers interesting facts about the surrounding area's modern attractions and varied past.

With a playground and a boat launch, Boom Island is a favorite picnic spot for local families. A century ago, this island was surrounded by log booms, awaiting processing at local mills.

53

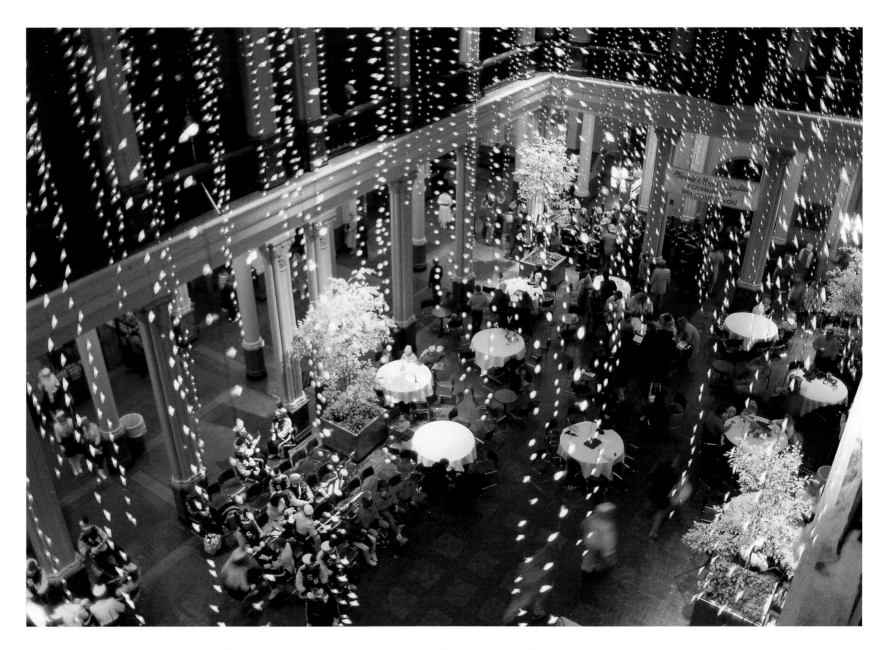

In the 1930s, St. Paul was home to famous gangsters such as Ma Barker, Baby Face Nelson, and Alvin "Creepy" Karpis. The federal courthouse at the time, Landmark Center, was the site of many high-profile gangster trials. The complex now houses the Minnesota Museum of American Art.

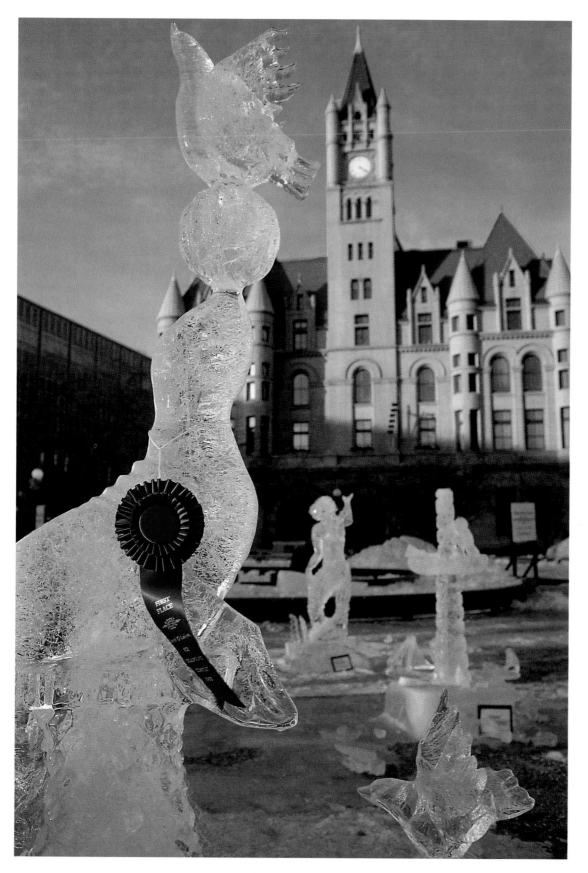

Ice sculptures, part of the St. Paul Winter Carnival celebrations, glisten outside Landmark Center. Some years, the carnival's attractions include life-sized ice palaces more than 150 feet high, complete with towers, turrets, and arches.

55

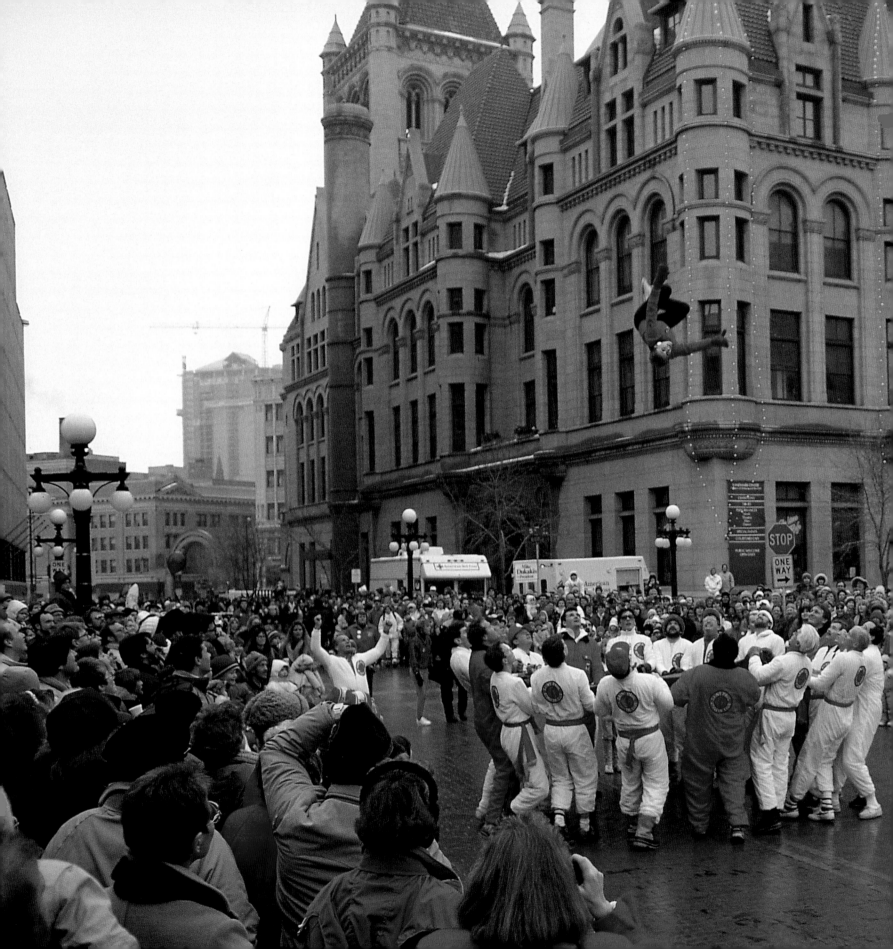

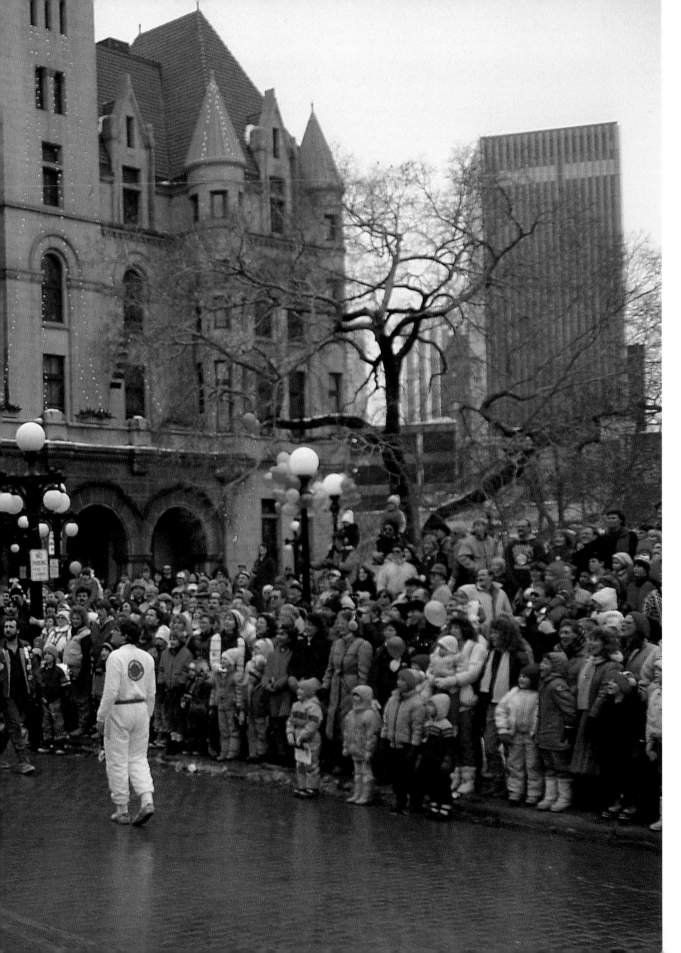

For more than 100 years, the St. Paul Winter Carnival—America's oldest and largest winter festival—has attempted to chase away the seasonal cold with a multitude of family events. Parades, ice and snow sculpting contests, ski races, and more keep the city entertained each January.

57

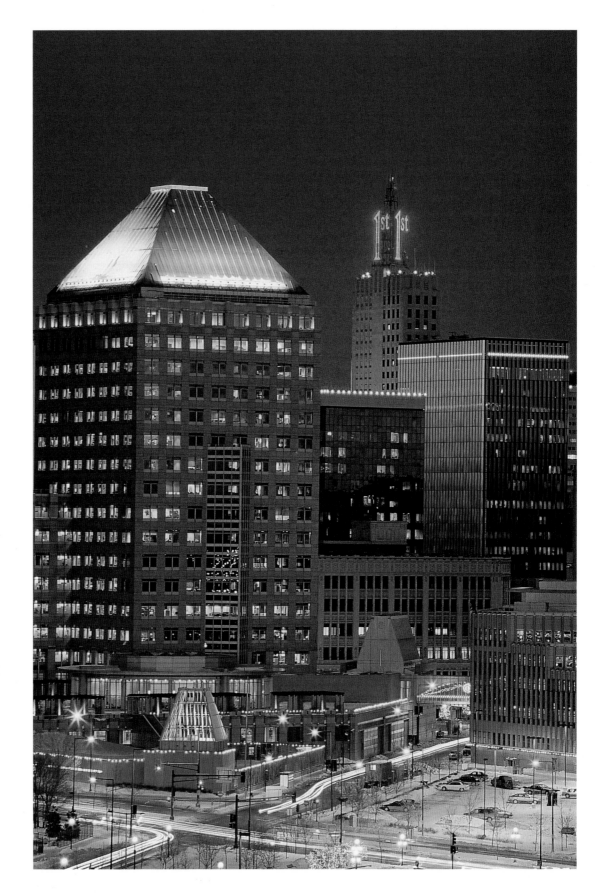

St. Paul was originally called Pig's Eye after settler Pierre "Pig's Eye" Parrant. Father Lucian Galtier renamed the community when he arrived in 1841 and St. Paul was named the capital of the territory eight years later.

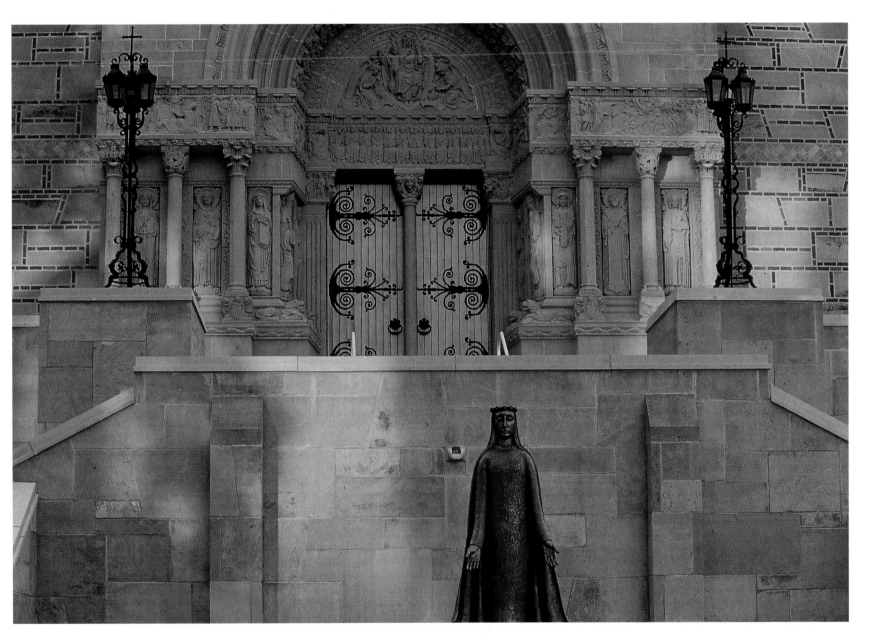

Almost 4,000 women attend the College of St. Catherine, the largest Catholic women's college in the country. Founded in 1905 as a center for studies in liberal arts, the school now includes many professional programs as well as a renowned nursing department.

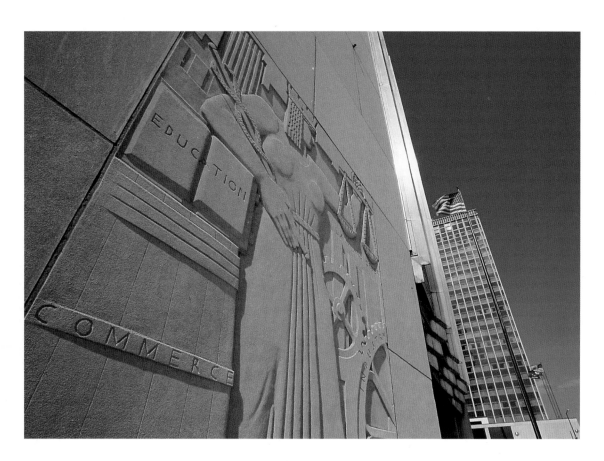

Ornate art adorns St. Paul's 20-story City Hall. The elaborate building, constructed of limestone and black granite, was built in the early 1930s.

The fountains and trees of Town Square are part of one of the world's largest indoor parks, on the fourth story of this downtown office and retail complex.

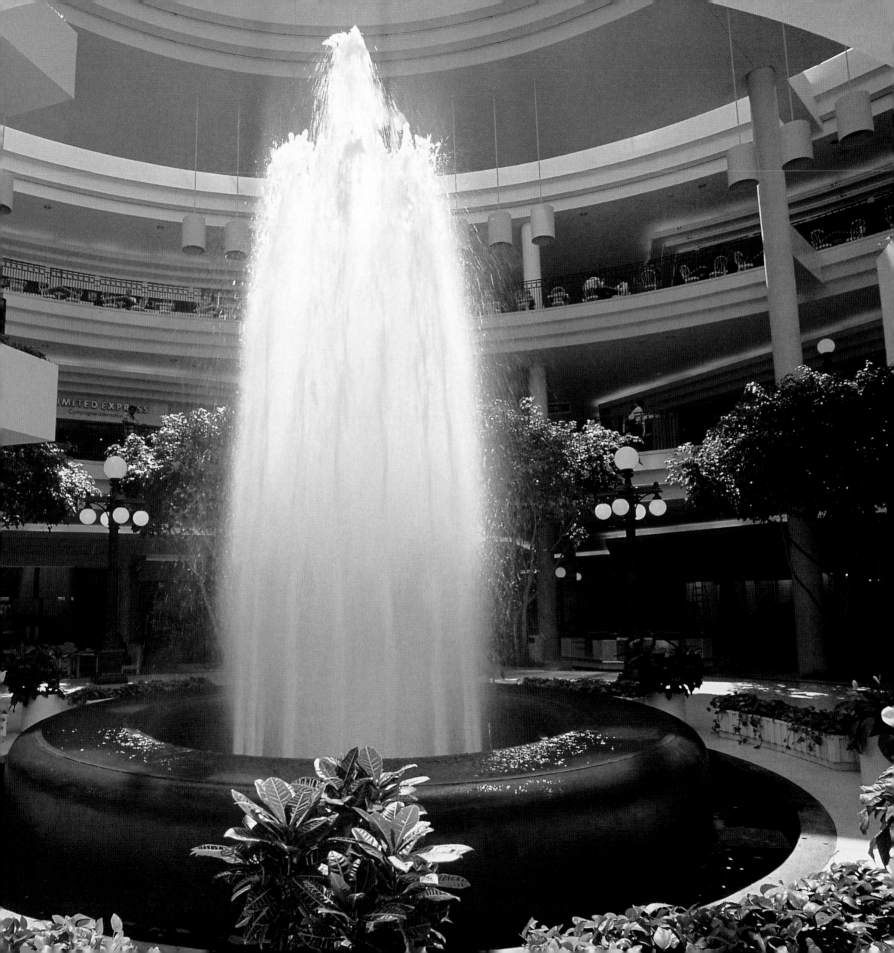

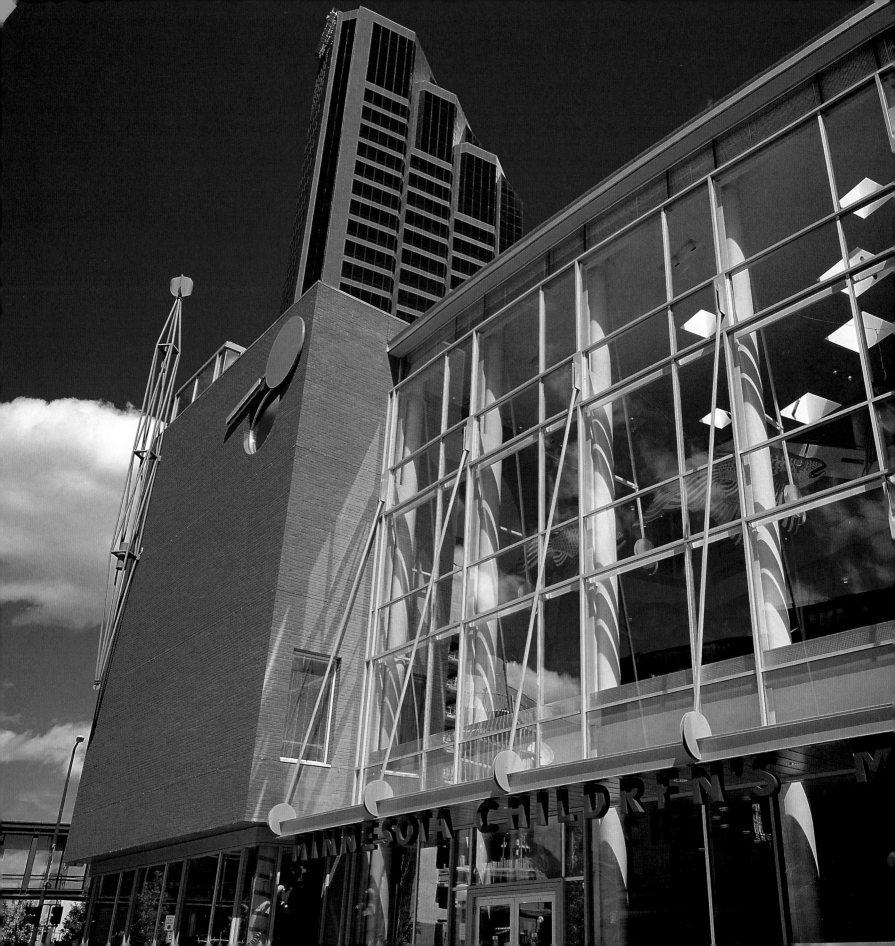

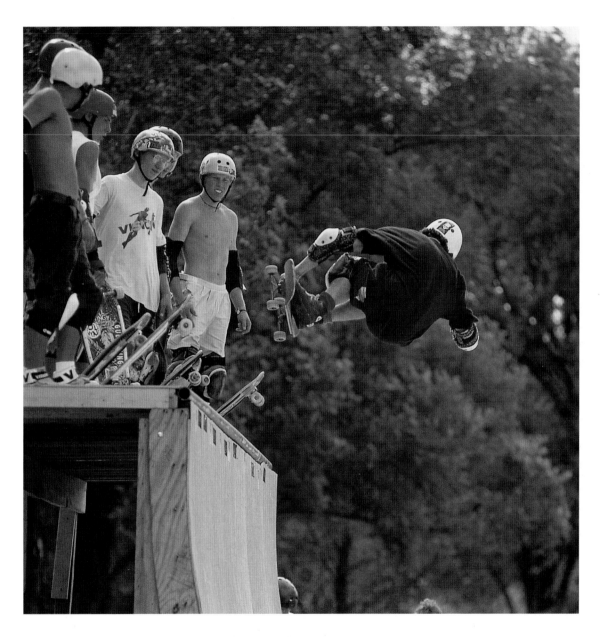

Young residents practice stunts at a local skateboard park. With attractions from the Como Park Zoo to the Science Museum of Minnesota, the Twin Cities are a wonderful place to live or visit with children and teens.

Interactive exhibits at the Minnesota Children's Museum include a giant anthill maze, animal habitats built to a toddler's perspective, and World Works, where children can invent their own gizmos.

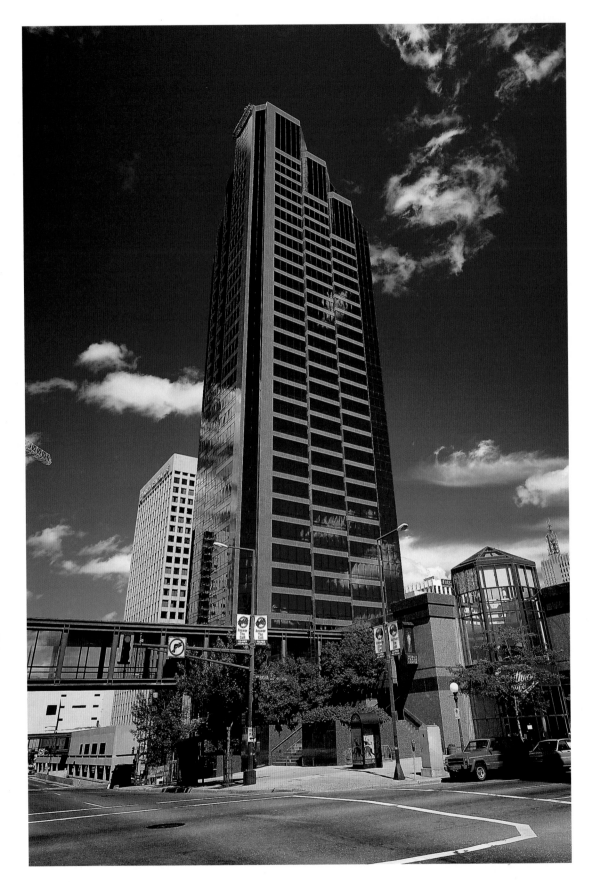

Towering 37 stories above the city, the World Trade Center is a dramatic part of St. Paul's skyline. The retail areas on the lower levels are constantly bustling with shoppers. Above, business people strive to realize the complex's purpose—to help develop international trade.

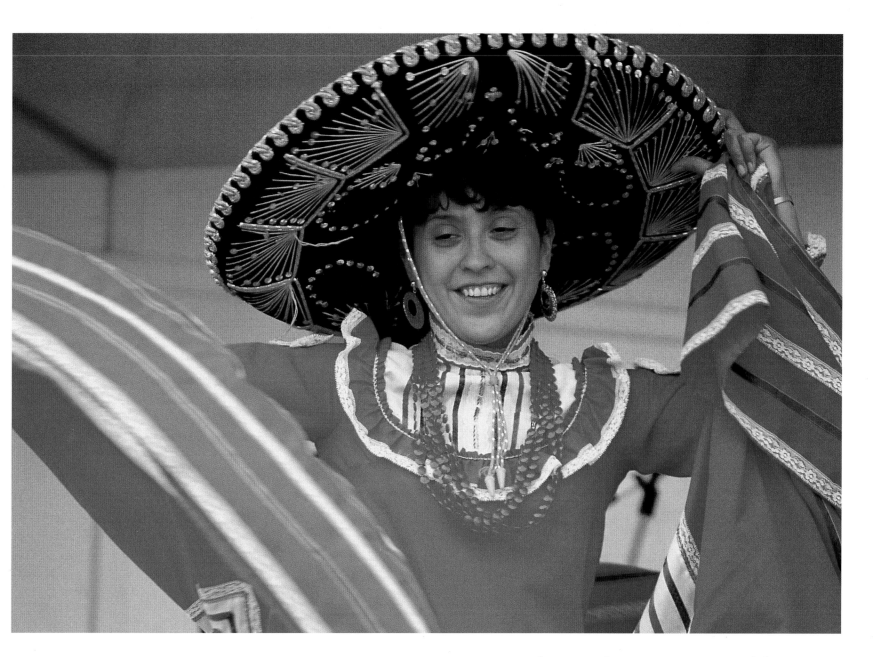

Drawing 60,000 spectators, the annual Cinco De Mayo celebration highlights the heritage and pride of Minnesota's Hispanic people. Events range from traditional dances to pinata contests.

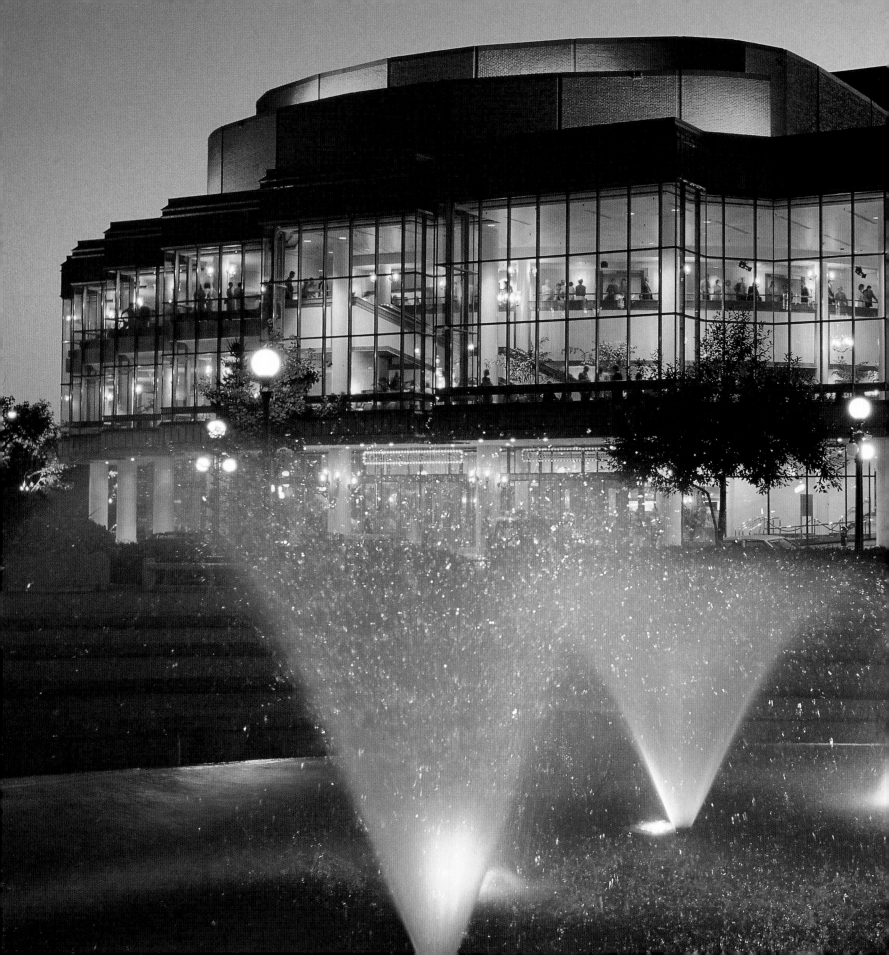

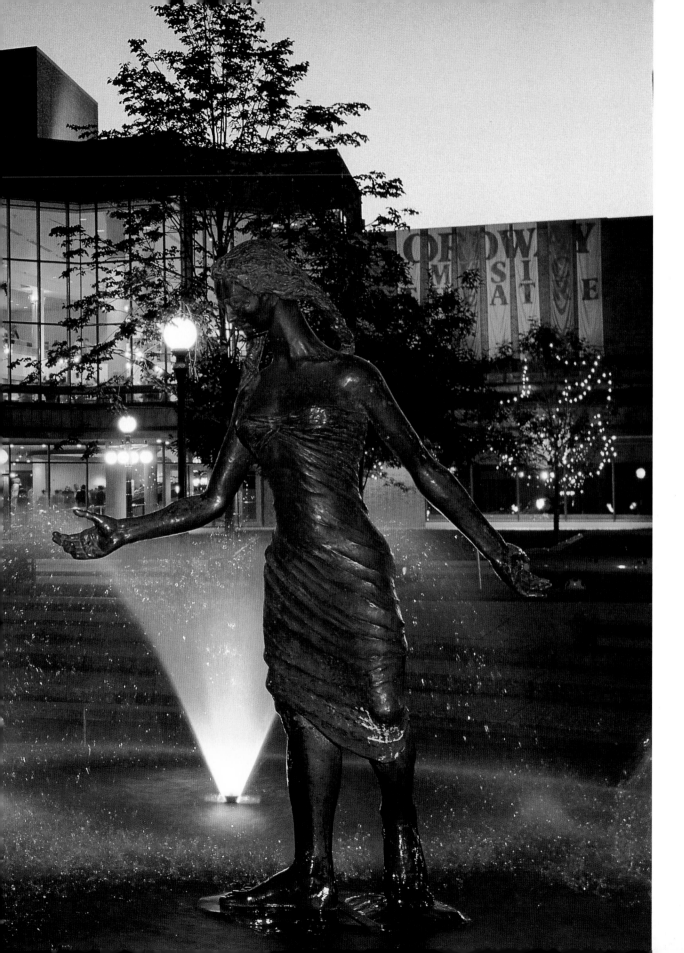

The stunning Ordway Music Theater is home to the Saint Paul Chamber Orchestra, the Minnesota Opera, and the Schubert Club. Built in 1985, the facility includes a 1,900-seat concert hall and a 322-seat theater as well as rehearsal rooms.

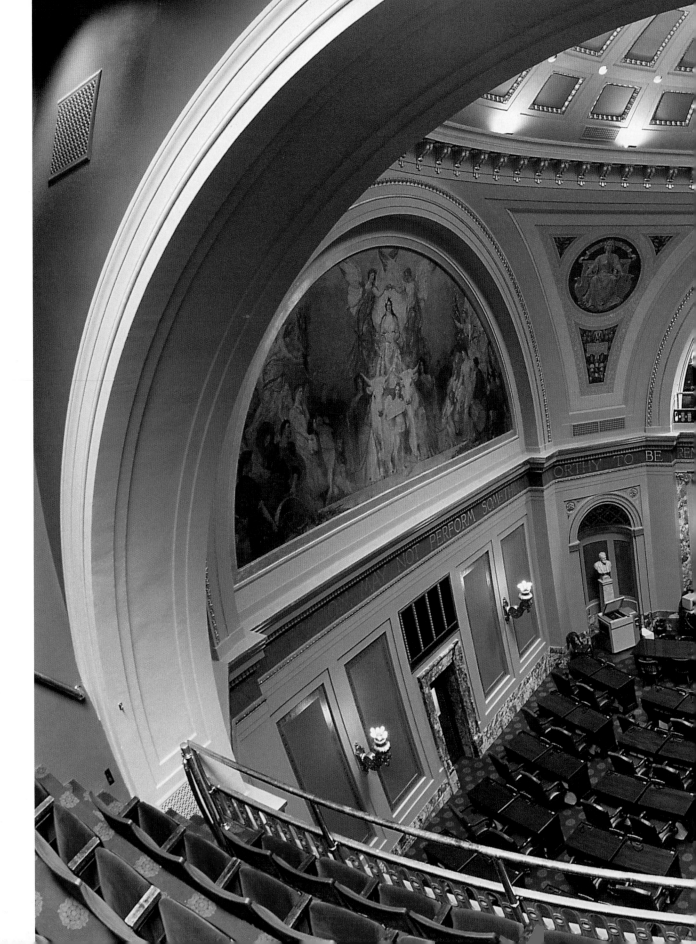

More than 20 kinds of stone were used to build the State Capitol, including red Minnesota pipestone. Visitors touring the interior gain a close-up glimpse of the ornate building as they learn about the state's rich history.

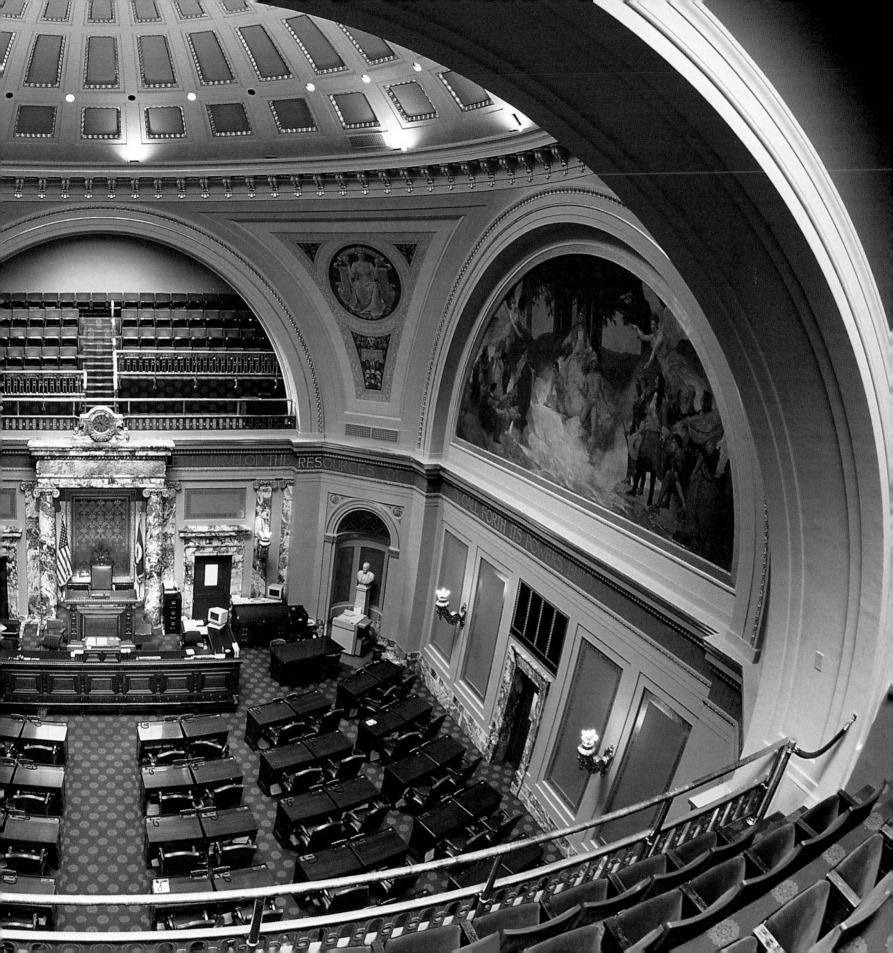

Designed in honor of St. Peter's Cathedral in Rome, the 3,000-seat
Cathedral of St. Paul was envisioned by Archbishop John Ireland,
who dedicated the structure to the people of the city. He died before
the cathedral's completion in 1925.

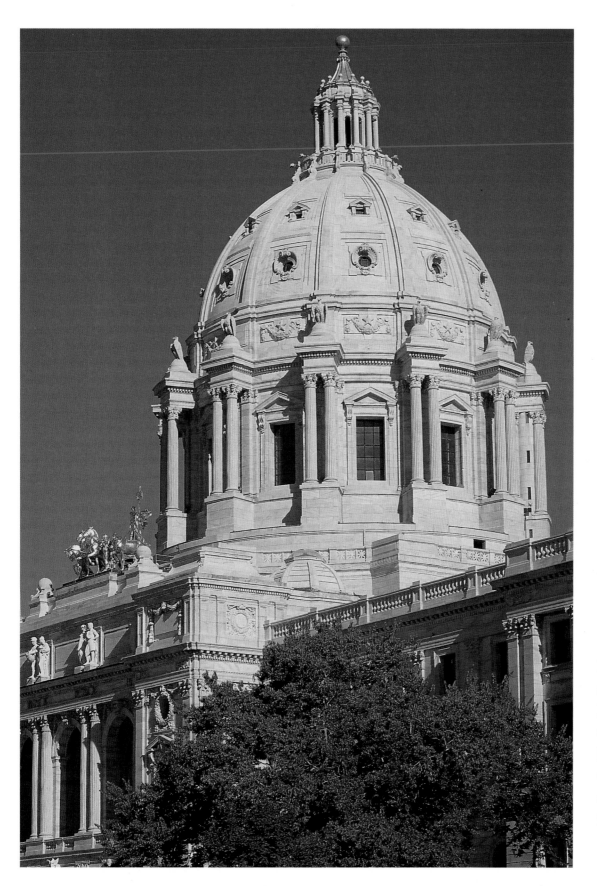

Built between 1896 and 1904, the Minnesota State Capitol was designed by architect Cass Gilbert, who also designed the U.S. Supreme Court.

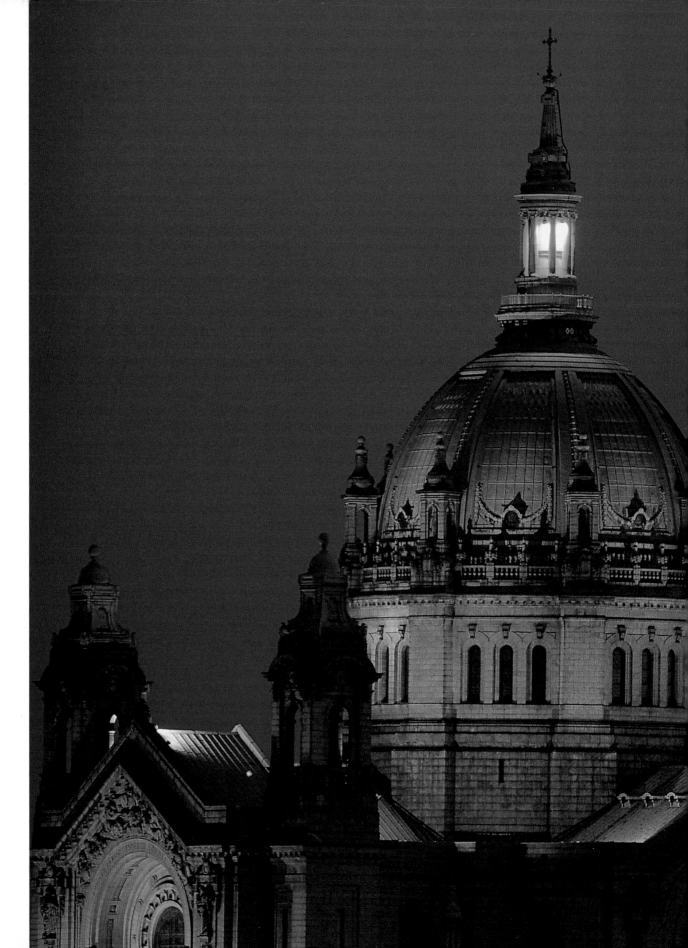

The dome of the Cathedral of St. Paul rises more than 300 feet and is adorned with 24 stained glass windows. The walls of the State Capitol are visible in the foreground.

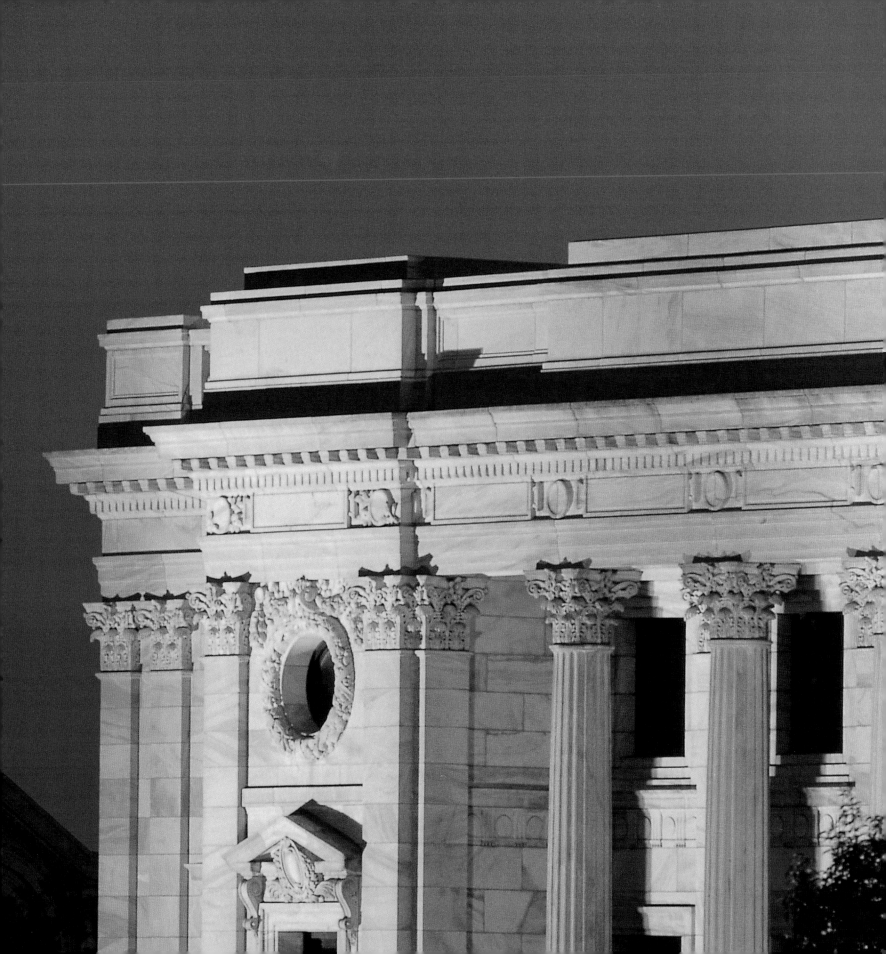

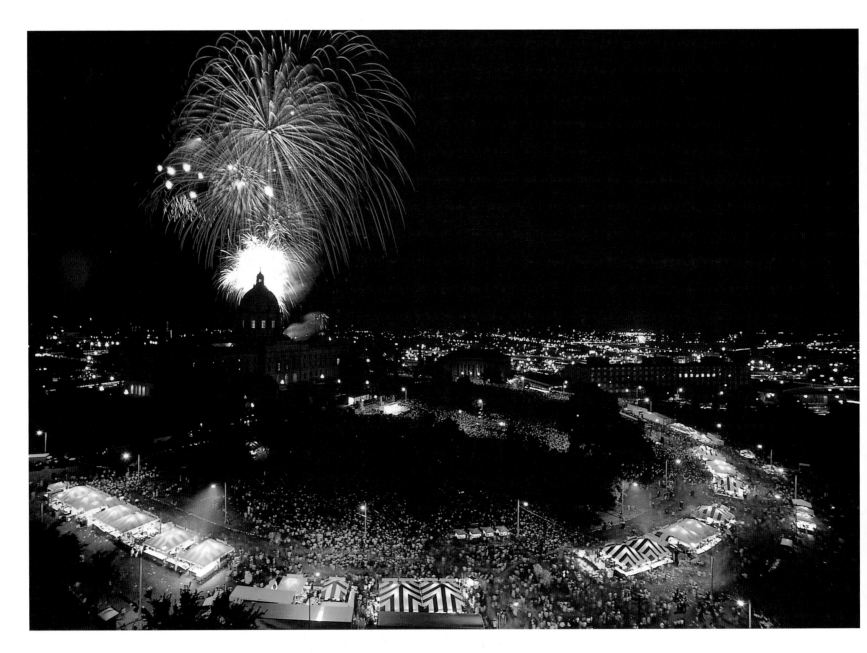

Fireworks light the sky over St. Paul on the fourth of July. Along with the pyrotechnics, the city celebrates the holiday with Taste of Minnesota, a festival of food centered around the State Capitol.

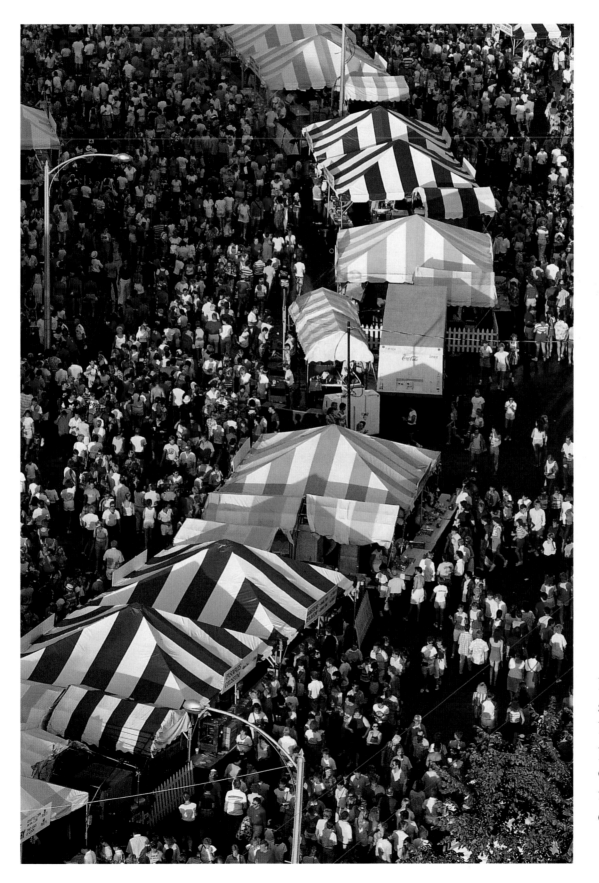

Revellers crowd the street during Taste of Minnesota, sampling portions from the city's best-known restaurants at the event kiosks.

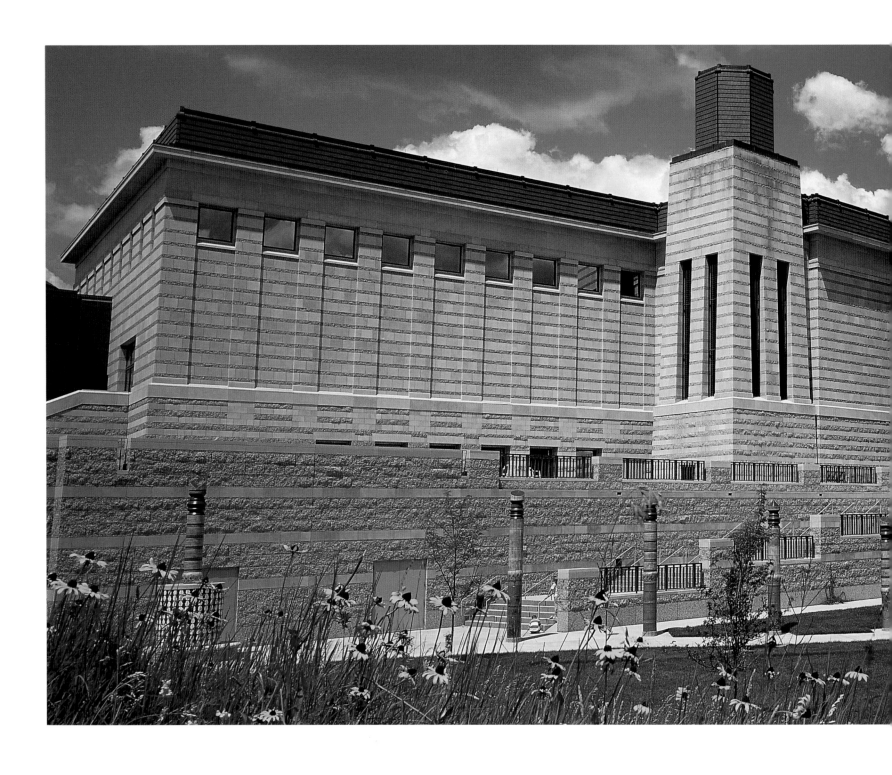

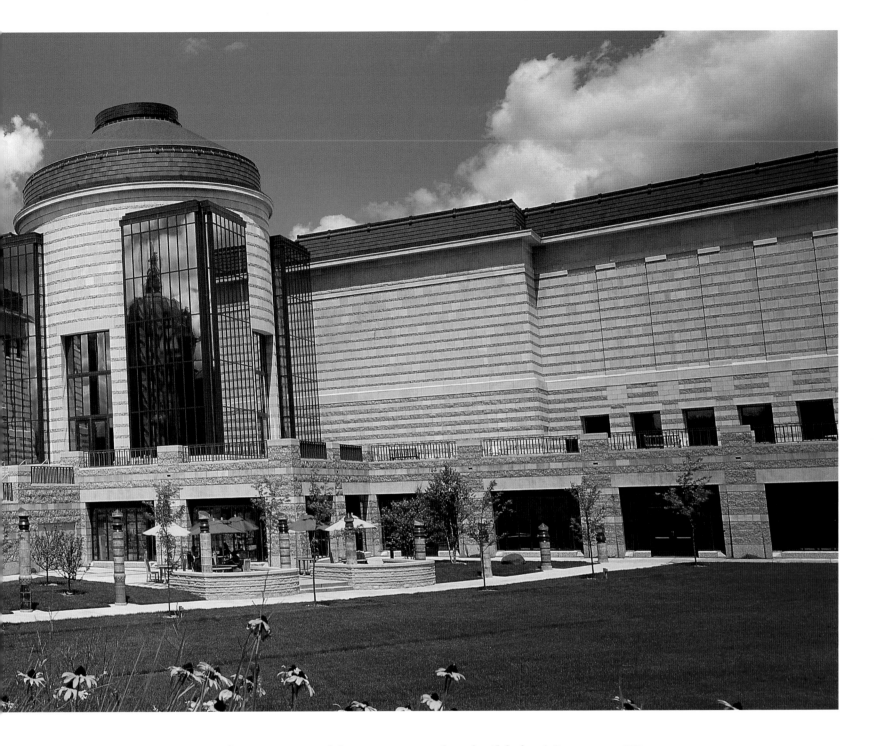

The granite and limestone used to build the Minnesota Historical Society History Center is native to the state. Visitors to the center can tour an interactive grain elevator, trace their family histories, or take an A to Z tour of Minnesota.

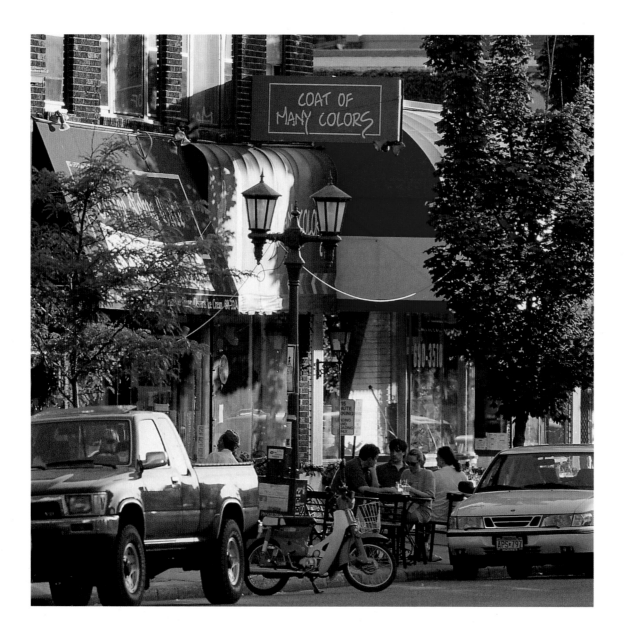

Lined with lively bistros and specialty shops, Grand Avenue is a popular shopping district. A wonderful place to wander, Grand Avenue offers everything from fresh bagels and used books to fishing flies and pottery.

Victorian mansions line prestigious Summit Avenue, a neighborhood that has been home to some of St. Paul's most famous residents. F. Scott Fitzgerald wrote his first novel, *This Side of Paradise*, while living here.

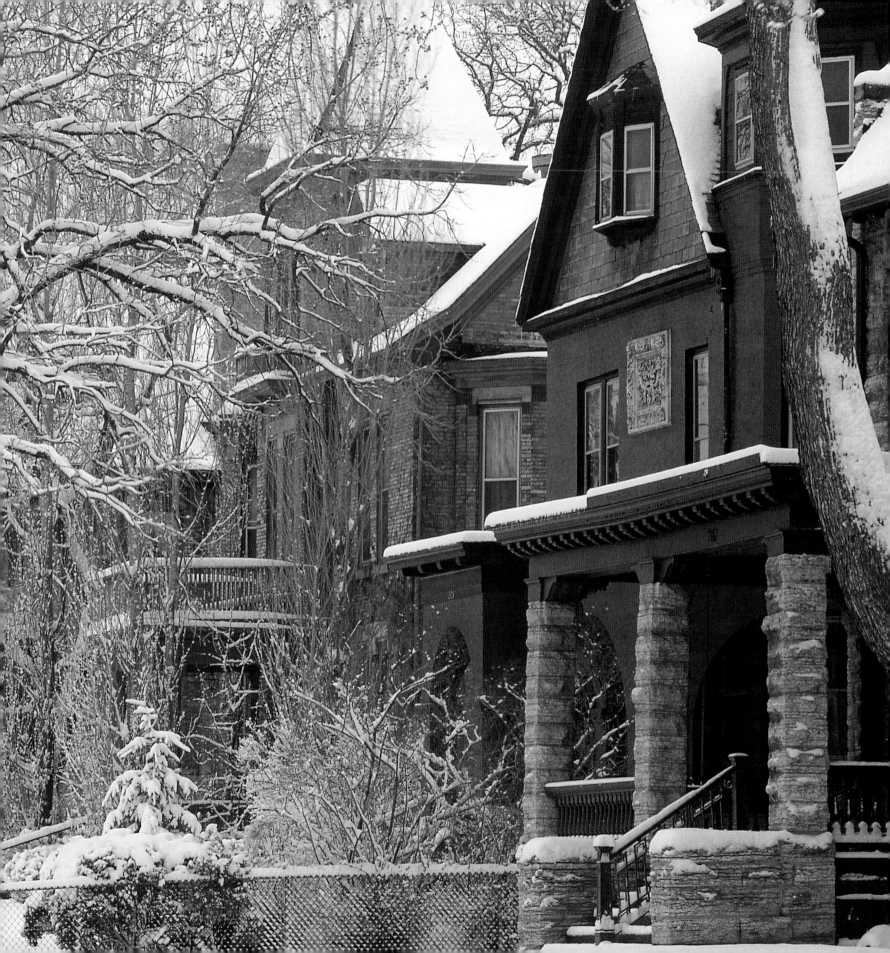

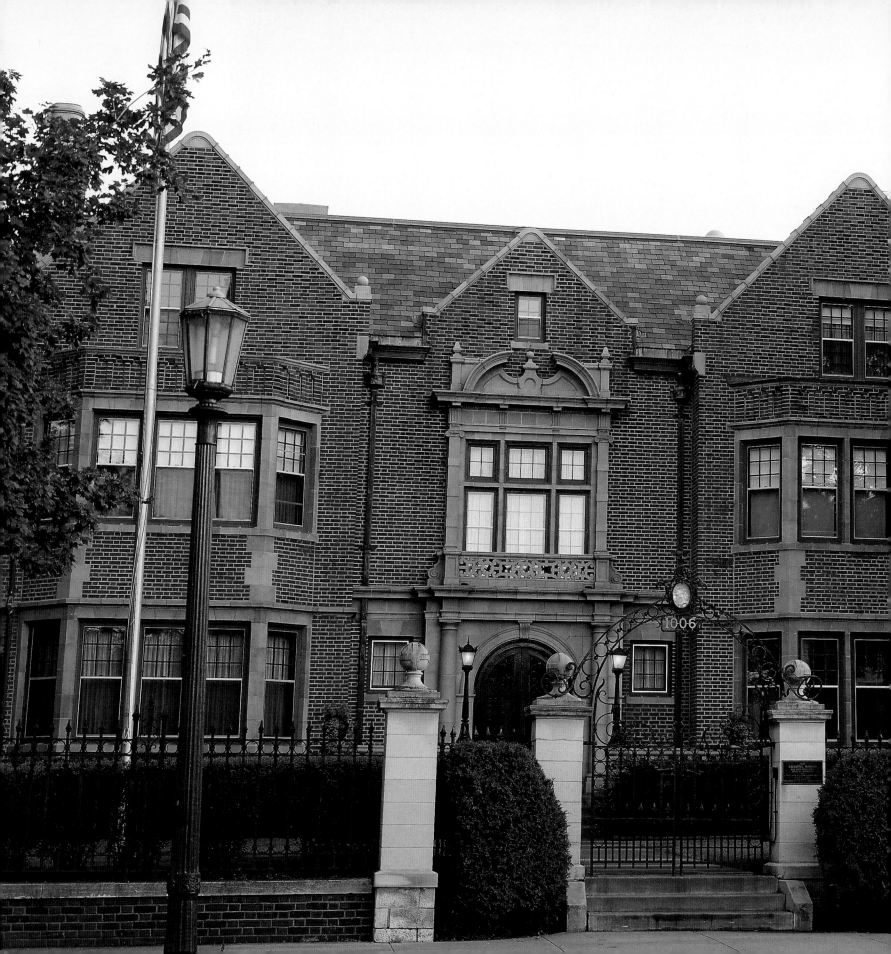

Built in 1910 for businessman Horace Hills Irvine, the Governor's Residence was created by architect William Channing Whitney. It has served as home to the state's leaders and a venue for official functions since the 1960s.

81

Though the spelling has shifted, Lake Phalen bears the name of Edward Phelan, one of St. Paul's more infamous pioneers. He was widely believed to be responsible for the violent murder of fellow settler John Hays in 1839, although he was acquitted of the crime.

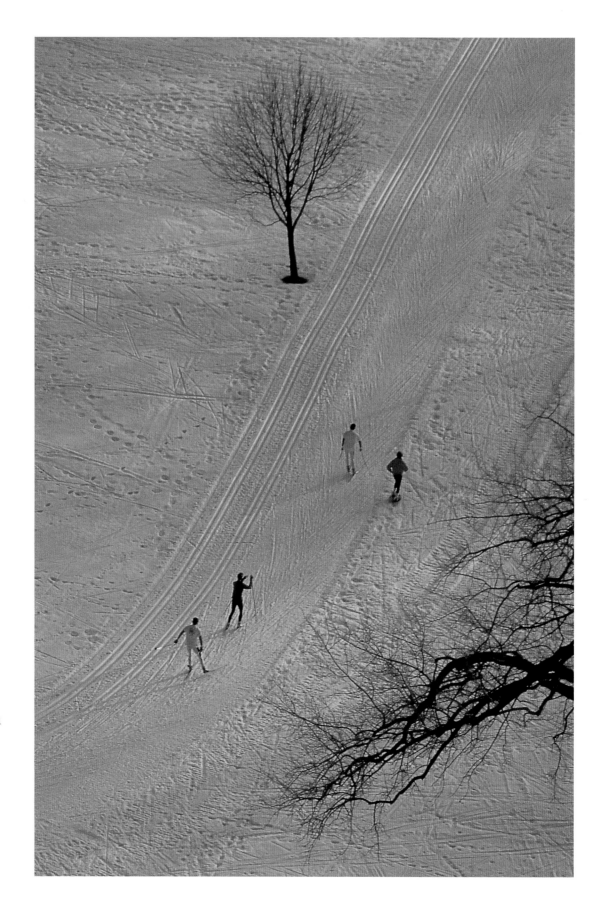

The picnickers who visit the lawns of Como Park in the summer enjoy cross-country skiing trails in the winter. There are also two downhill ski runs within the park.

A host of famous celebrities once called the Twin Cities home. Loni Anderson was raised in St. Paul, Jessica Lange attended the University of Minnesota, and the artist formerly known as Prince was born in Minneapolis.

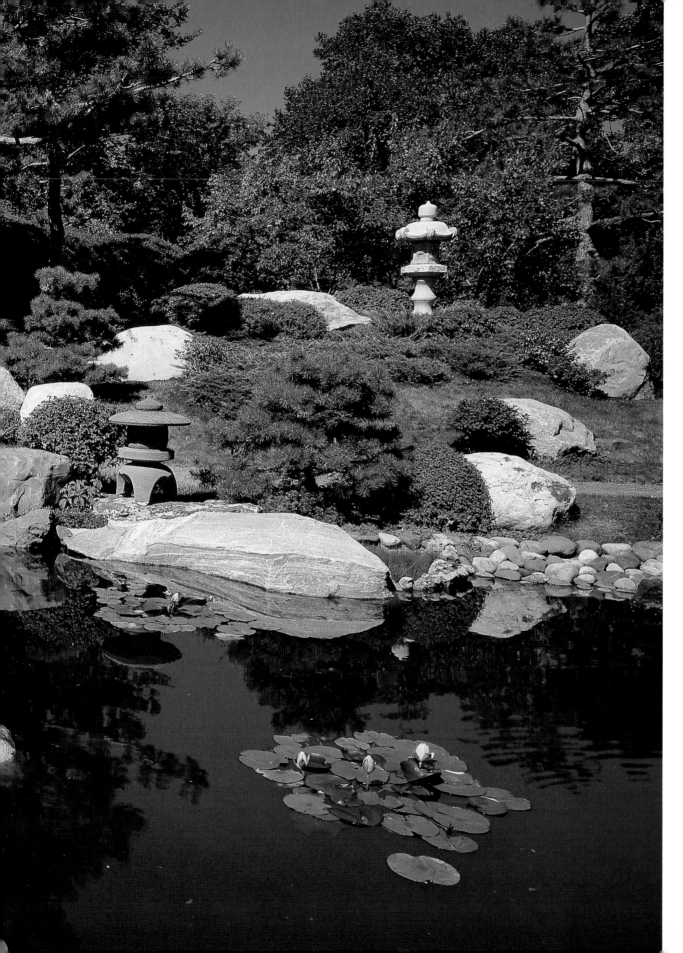

A golf course, a lake, a zoo, a conservatory, and more—Como Park offers enough attractions to draw more than one million visitors each year. The park encompasses 450 acres to the northwest of downtown.

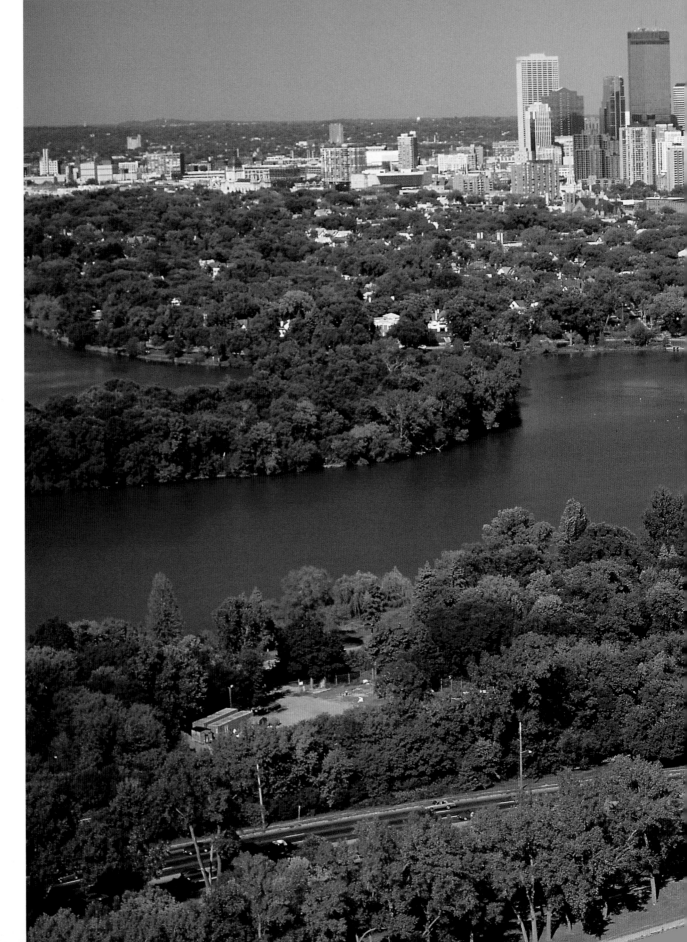

Fascinating Native legends surround the Twin Cities area. According to one tale, the spirit of beautiful Anpetu Sapa can be seen in the mist over the Mississippi. Heartbroken when her husband married a second wife, Anpetu Sapa dressed in her bridal clothes, paddled into the Mississippi River, and took her life.

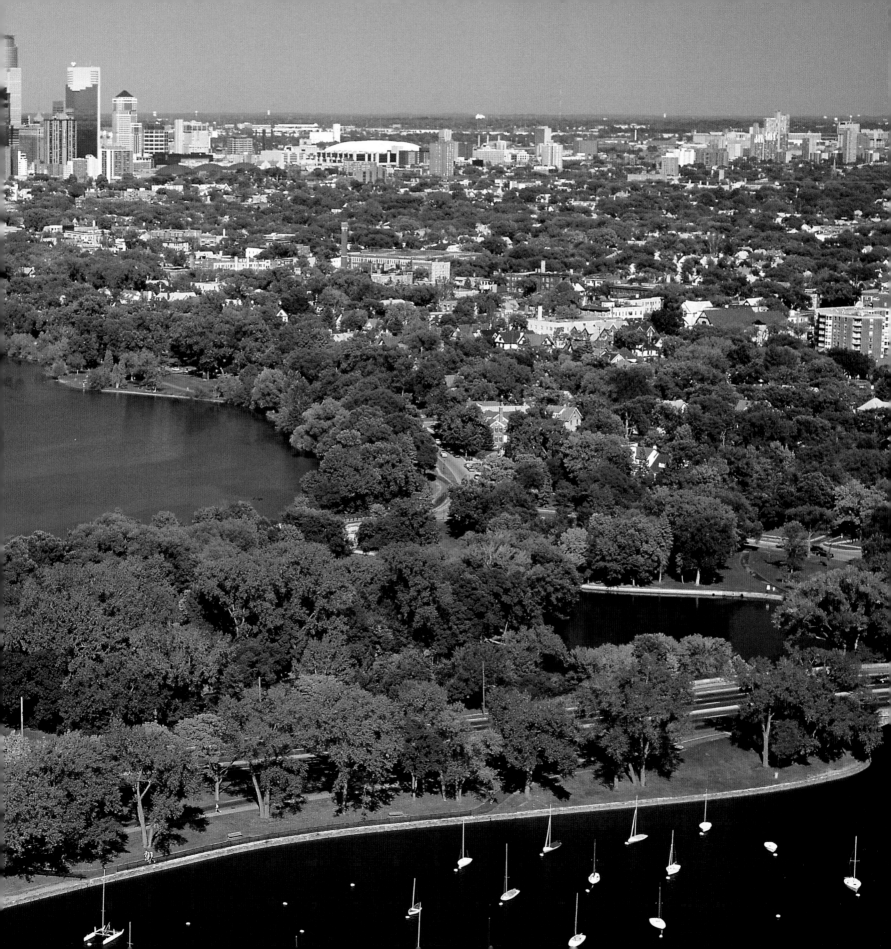

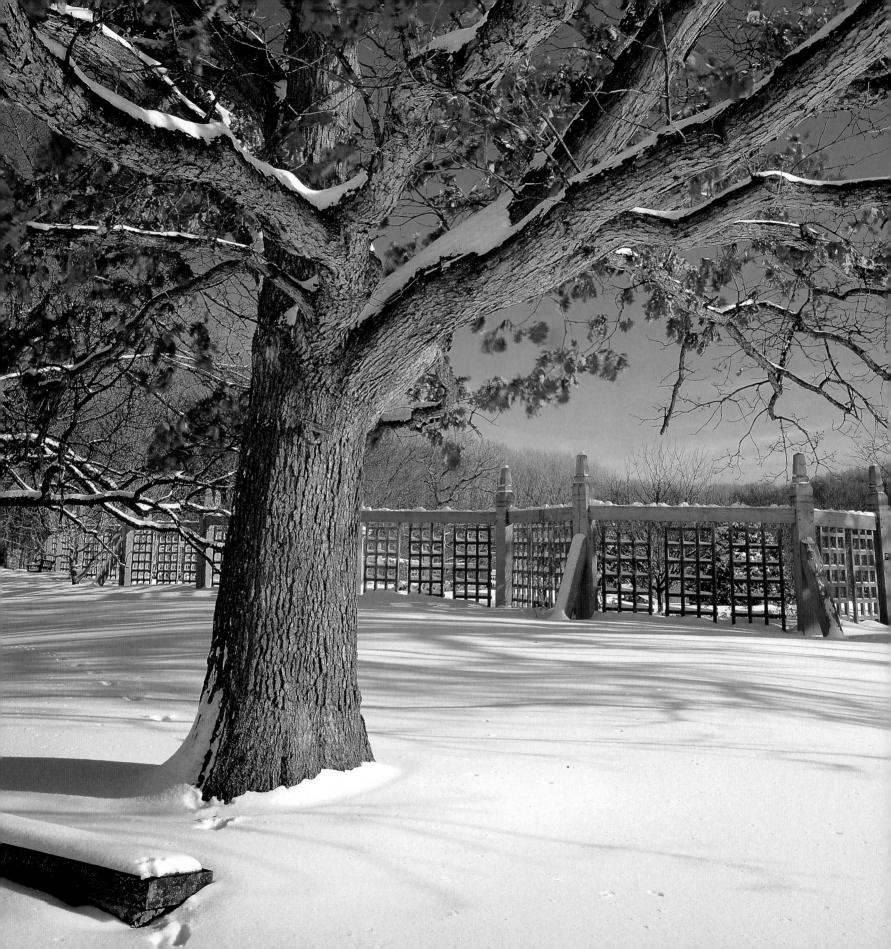

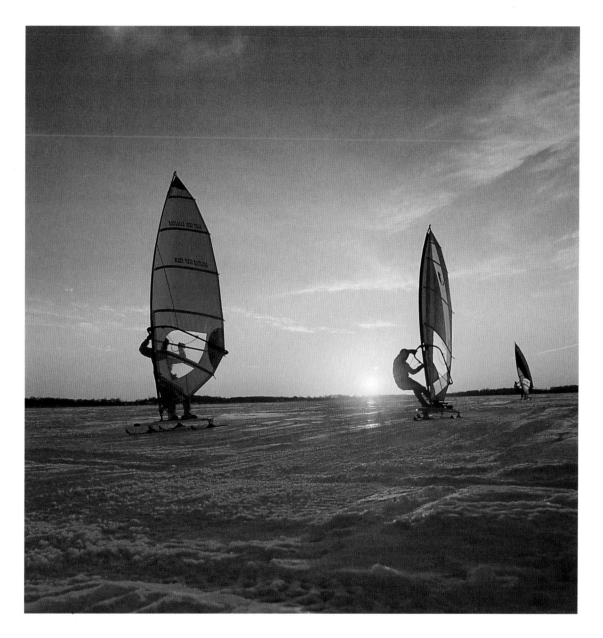

Winter sports enthusiasts find their thrills snowsurfing on Lake Minnetonka. Other popular winter sports include skiing at Como Park and ice skating on the local waterways.

Only a half-hour drive from the city, the Minnesota Landscape Arboretum encompasses 900 acres, including both formal gardens and native prairie.

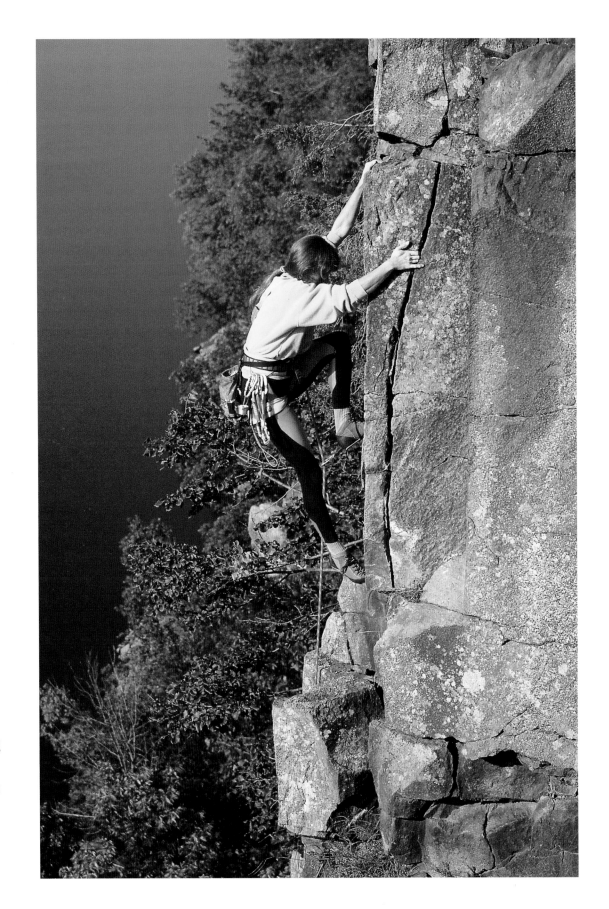

A rock climber clings to a bluff near Taylors Falls in Interstate Park. Extending across the St. Croix River into Wisconsin, it was the first interstate park in the nation.

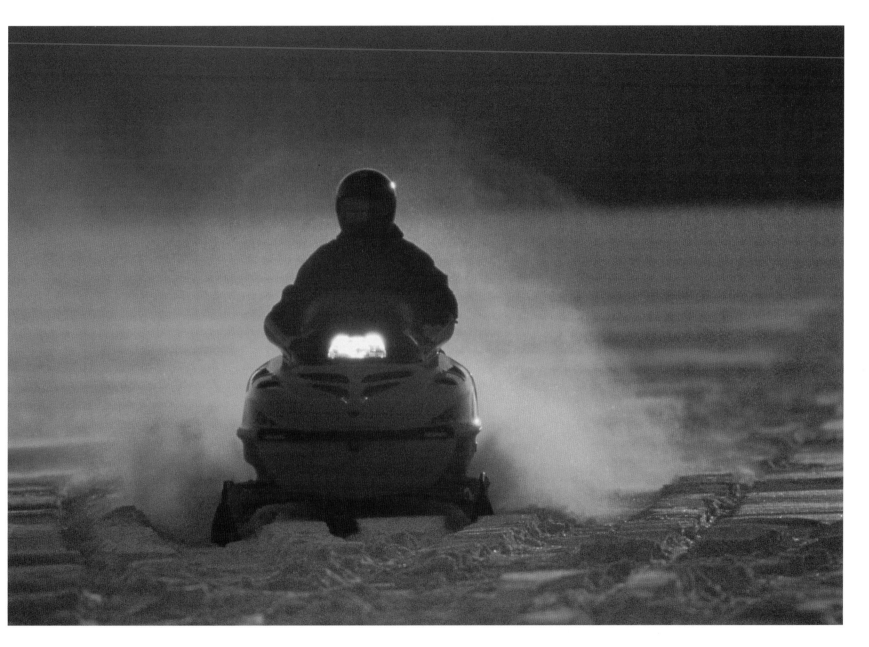

The second coldest city in the country, Minneapolis has an average January temperature of 12°F and receives about 40 inches of snow each winter.

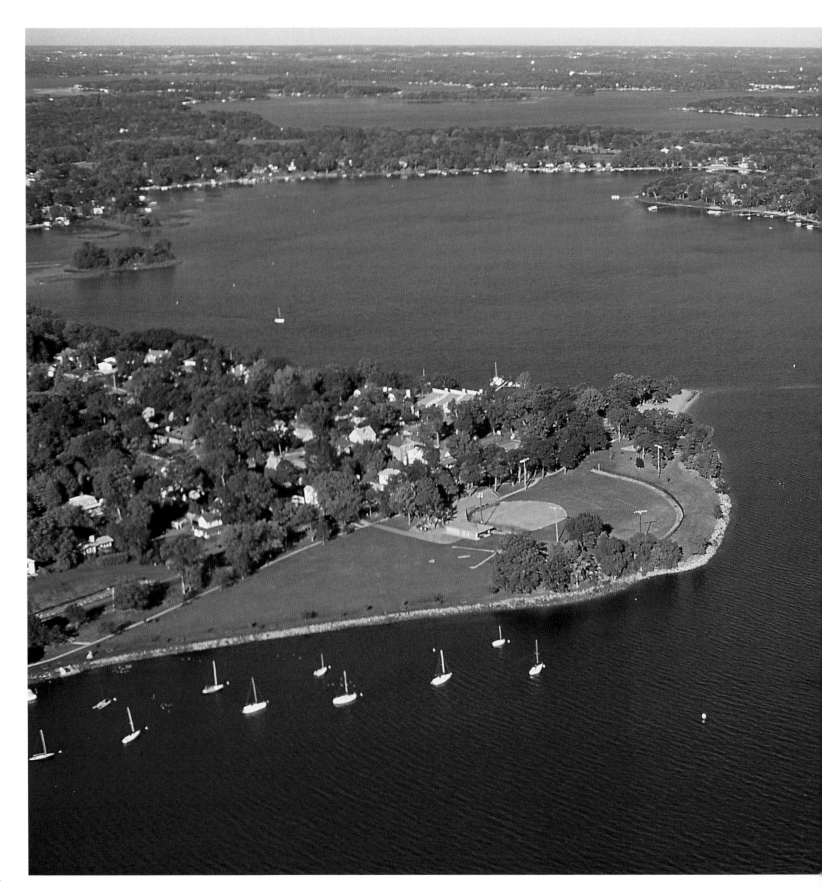

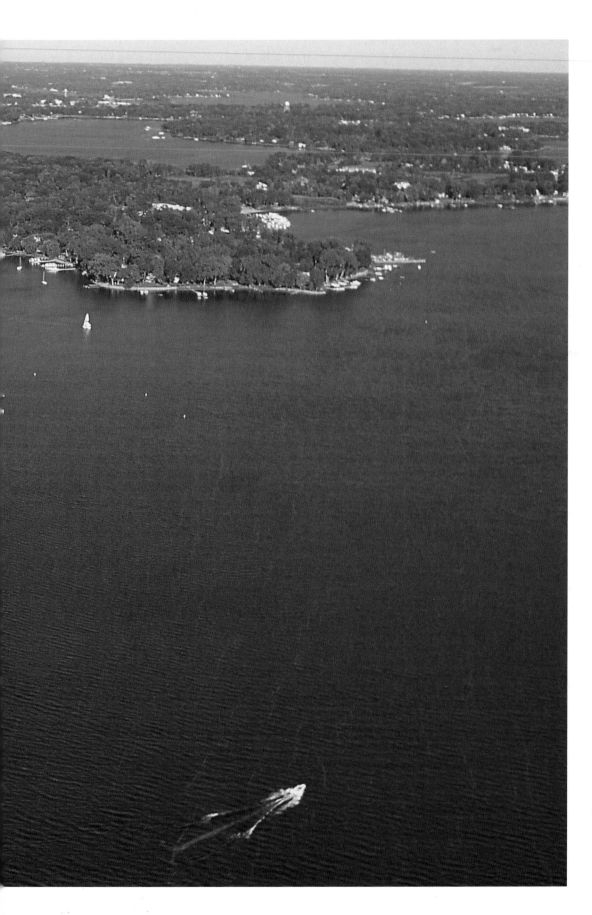

One of the largest lakes in Minnesota, Lake Minnetonka is a maze of bays and channels with more than 100 miles of shoreline. About a 15-minute drive away, the area is a favorite weekend escape for residents of the Twin Cities.

Photo Credits

BOB FIRTH/FIRST LIGHT 1, 3, 6-7, 8, 9, 10, 12-13, 14, 15, 16-17, 18, 22, 23, 25, 28-29, 30, 34-35, 36, 37, 38, 39, 44, 45, 46, 47, 48-49, 51, 52-53, 62, 64, 66-67, 71, 76-77, 80-81, 82-83, 86-87, 88-89, 90, 92

RICHARD HAMILTON SMITH 11, 19, 26-27, 31, 41, 42-43, 58, 59, 60, 61, 65, 68-69, 70, 72-73, 74, 75, 78, 79, 84, 85, 94-95

STEVE SCHNEIDER/FIRST LIGHT 20-21, 24, 32, 33, 40, 50, 54, 55, 56-57, 63, 91, 93